A Collector's Guide to
MODERN AUSTRALIAN
CERAMICS

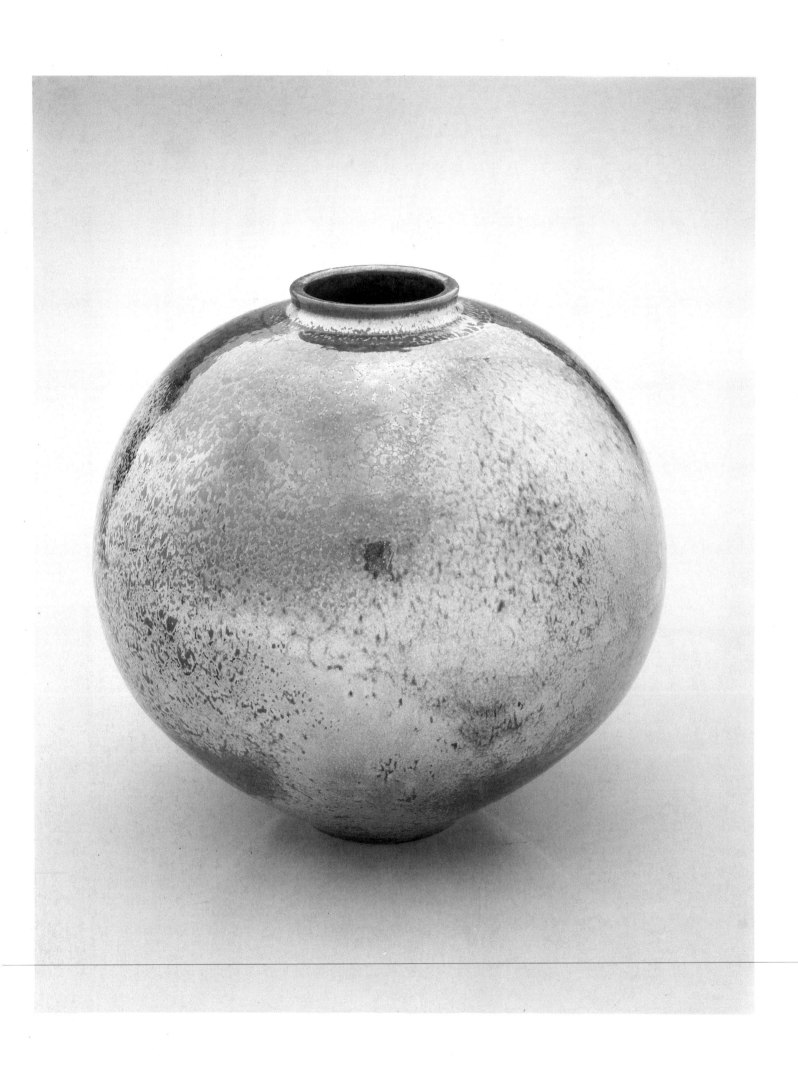

A Collector's Guide to

MODERN AUSTRALIAN CERAMICS

Janet Mansfield

CRAFTSMAN HOUSE

Photographic Credits

First published 1988 by Craftsman House
a division of The Craftsman's Press Pty. Limited,
11 Burnt Street, Seaforth, NSW 2092,
Australia

Copyright © 1988 Janet Mansfield

National Library of Australia
Cataloguing-in-Publication data

Mansfield, Janet.
 A collector's guide to modern Australian
 ceramics.

 Bibliography.
 Includes index.
ISBN 0 947131 09 4.

 1. Pottery – 20th century – Australia.
 2. Potters – Australia. 3. Pottery,
 Australian – Collectors and collecting.
 I. Title.

738'.0994

Publishers	Geoffrey M. King & Nevill Drury
Art Director	Judy Hungerford
Desiger	Patrick Coyle
Printer	Kyodo, Singapore
Typesetter	Deblaere Typesetting Pty. Limited, Sydney

pages 12, 13 *left*, Art Gallery of Western Australia; page 16,
John Storey; pages 23, 24, Douglas Thompson; pages 25, *right*, 26,
Skip Watkins; pages 35, *right*, 51, 58, 62, 65 *bottom*, 99, 100, 111,
Roger Decker; pages 69, 118, R. Bruce; page 70, *right*, Victor
France; page 71, John Austin; page 93, Byron Nichols; page 108,
Grant Hancock; page 113, Jeannie Keefer Bell

title page
Greg Daly, lustre glazed pot

CONTENTS

INTRODUCTION

'Tell us about modern ceramics, tell us what today's artists working in the clay medium are saying with their work? Why should we collect individually designed and hand-made pottery to use and to decorate our environment? Is there a modern ceramic movement which is making a statement about contemporary artistic and social issues?' These questions can be heard from critics, collectors and the public. More and more artists are using clay for personal expression and creativity, for traditional uses and new ideas; yet knowledge of the motivation of these ceramists and the understanding of their work has, seemingly, not kept pace with the excitement of the ceramists themselves.

The purpose of this book is to present to collectors, public and private, information on Australian ceramists and to provide a perspective on their work. This book looks at individual artists and how they are exploring the potential of clay, using traditional or innovative techniques to make relevant comment on aspects of our society. With knowledge of the background, intention and skills of these artists, their work can be recognised and understood. Written statements from the artists account for the major part of the text. In addition, I have brought together critical comment on their work and attitudes in order to provide a comprehensive account for the collector on contemporary ceramics in Australia.

The choice of the ceramists in this book is a personal one, a selection from those whom I consider to be artists of stature working in the fields of functional, decorative and sculptural ceramics. Some of these ceramists have been long established, teaching, exhibiting and influencing others; some are newly emerging into the field, beginning to exhibit their work and commanding some critical attention. Collectively, they show the diversity possible in using clay as an expressive material and they show the vitality of the art craft movement in Australia today, leading possibly, I wonder, to the development of a nationally identifiable style. Individually they show the artistic and creative objectives that have resulted in new forms, the use of symbolic imagery, figura-

tive and narrative work, new ideas for contemporary utensils or rituals and the development of personal and recognisable styles. The use of materials and processes as exploited by the potter, clay as a canvas for the painter/potter, the influences of cultures admired or inherited, or of social issues, and, above all, aesthetics, are the concerns of these ceramists.

That these ceramists show a mastery over their materials, know and enjoy the processes of technique and fire, and can use their skills with imagination and honesty is taken for granted. The list of their exhibitions, awards, representations in collections and publications is impressive and only briefly referred to in the text. I have given some details as to college and other training, to show that Australian artists, painters, sculptors and craftspeople, all share a similar background and attitude. It is not only skill, but the continual exploration of ideas, as well as the risk taking and experimentation with new techniques to keep pace with those ideas that makes these ceramists so outstanding.

How does one judge good work? How does one recognise excellence? Has the potter communicated what is a clear, unambiguous achievement in the work? If the intention of the maker is clear, if the ideas behind the work speak clearly or deliberately intrigue, then the work is successful. The scope of this book does not allow me to cover all the excellent work being made in Australia today. However if I can clarify the intention of some ceramists and aid the understanding of their diverse expressions in ceramic art, my purpose in widening and deepening the appreciation of ceramics will be well served. Museums and public art galleries are increasingly interested in collecting ceramics as well as exhibiting new work in clay. There are many publications, magazines and books on all aspects of ceramics. Colleges throughout Australia offer courses at high levels in ceramic art, there are many groups of professional ceramists, and conferences are held regularly – attracting hundreds. Thus it is important to set some criteria for judgement.

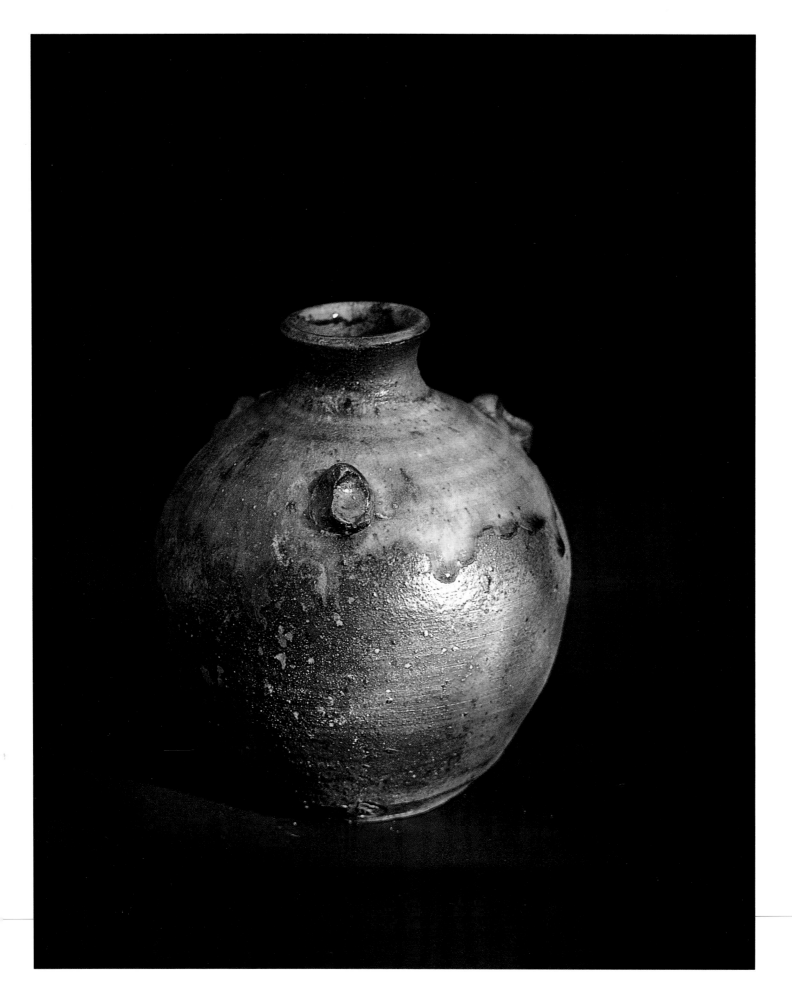

1

THE PIONEERS WHO SET STANDARDS

Fired clay objects have had a place of importance in society for thousands of years and from the ceramics of any particular civilisation one can learn something about the artistic values, technology and the culture of a people. It is in Australia that the earliest known fired ceramics have been discovered, dating back to some 30,000 years or more. Clay *stones,* hardened in cooking fires, have been located in the Murray River area of south western New South Wales.[1] Apart from these primitive ceramics, the Aboriginal people of Australia made no pottery, so Australian ceramic traditions began elsewhere, being brought to this country with the European settlers during the last two hundred years.

The pottery and other ceramic pieces made in Australia during the nineteenth century and in the first half of the twentieth century have now become of great interest for the historian and the connoisseur and indeed do give us the basis of a tradition and perhaps point the way to a developing and distinctive Australian style. The needs and the cultural circumstances of any community are reflected in the ceramics made at that time, and our history is rich with potters, their quest for materials and technology, and their artistic perceptions. In his book, *Australian Studio Pottery and China Painting*[2], Peter Timms has covered the history of events and people concerned with ceramics in Australia until the 1960s with particular emphasis on the period before the Second World War. The influence of the Arts and Crafts Movement, founded by William Morris, the increasing availability of technical education in the arts, and the establishment of the arts and crafts societies in each State are all part of the tradition inherited, and slowly becoming appreciated, by today's artist craftspeople.

During the past three decades, the interest in ceramics as professional practice has accelerated rapidly. Through the publication of Bernard Leach's *A Potter's Book*[3], the possibility of a professional livelihood from pottery, involving the making of stoneware and using Oriental glazes, became a serious consideration. Harold Hughan, Ivan McMeekin and Peter Rushforth were amongst the first of Australia's potters to take up the challenge of the high-firing techniques of stoneware as described by Bernard Leach. The Leach philosophy, based on Japanese folk craft and English slip ware, combined the two aesthetic standpoints of beauty and usefulness. This philosophy is still a valid one, gaining more adherents as both potters and the public come to appreciate the individuality, the human touch and the self-realisation achievable.

Peter Rushforth, blossom jar, wood fired, natural ash glaze

1 A Preliminary Investigation of Aboriginal Mounds in North-Western Victoria', by P. J. F. Coutts, P. Henderson and R. L. K. Fullager published in the Records of the Victorian Archaeological Survey, No. 9, August, 1979.

2 See *Australian Studio Pottery and China Painting,* Oxford University Press, published 1986

3 *A Potter's Book,* published by Faber and Faber, 1940

Peter Rushforth, blossom jar, wood fired stoneware, *Chun* glaze

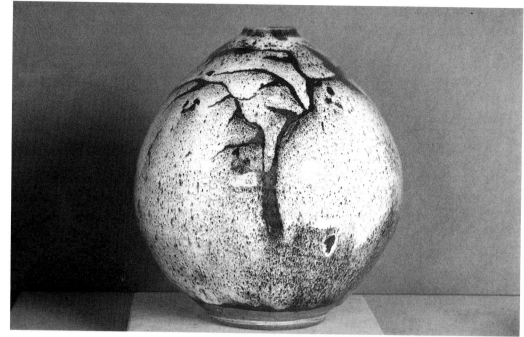

A family collaboration of the Hughans, Harold, his wife and son Robert led, in 1943, 'to the development of the first successful stoneware bodies and glazes made from Australian raw materials, which were used to achieve the rich celadon and tenmoku glazes about which Bernard Leach had so eloquently written only a few years before.'[4] Harold Hughan, from then till now has continued to make jugs and casseroles, storage jars and especially the large platters for which he is well known. Two retropectives of his work have been staged at the National Gallery of Victoria. Kenneth Hood, Deputy Director of the National Gallery of Victoria describes Hughan as 'the most widely respected potter in the country' and writes in the catalogue for the 1983 exhibition: 'The pots he has made – and is still making – are deceptively simple... Produced seemingly with complete naturalness, they have an elegance and sophistication born only of a complete empathy with the clay.'[5] Kenneth Hood concludes: 'The pots are of the first importance in the story of pottery in Australia and one of its most notable achievements. The pleasure which they have given – and will continue to give – to a great many people, coupled with the dignity and influence of his life and work has guaranteed Hughan's place in the history of Australian twentieth century ceramics.'

A similar desire to make pots that people could believe in, that showed the interaction between a potter and the materials, brought Ivan McMeekin back to Australia after working with Michael Cardew (potter, author and early student of Bernard Leach) in England. McMeekin wrote: '1956 found me struggling to establish the Sturt Pottery in Mittagong. I saw this as a wonderful opportunity to develop an Australian style or idiom, based on the concept of making materially useful pottery as a fine art... I felt that the straight forward making of useable pots could act as a vehicle for expression for the human spirit.'[6] His book, *Notes for Potters in Australia*, has enabled many potters to use local materials in their work, with understanding and enjoyment for their specific qualities.

Australian trained, Peter Rushforth, during his 27 years teaching ceramics at East Sydney Technical College, has exerted considerable influence on the development of ceramics in Australia. He has inspired many to become potters, not only through his teaching but also from the regular exhibitions of his pottery. Peter Rushforth commenced training as a potter in 1946 at the Royal Melbourne Institute

4 *A 40 year Family Double*, by Randolph Booth, *Pottery in Australia*, Vol. 22/2 1983

5 From the catalogue, written by Kenneth Hood, Deputy Director of the National Gallery of Victoria, for the second retrospective exhibition of the work of Harold Hughan, in 1983, to mark Hughan's 90th birthday

6 Article *1956-1981, As it's Been for Me*, published in *Pottery in Australia*, Vol. 20/2, 1981

7 *Notes for Potters in Australia* Ed. II, published by N.S.W. University Press, 1985

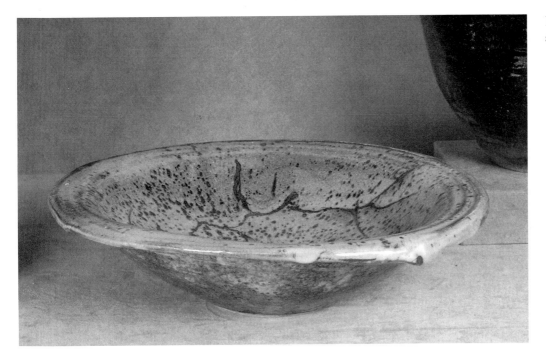

Peter Rushforth, platter, wood fired stoneware, *Chun* glaze

of Technology. He continued his studies at the Gallery School and then later at the National Art School in Sydney. In 1949, he worked as an independent potter in Victoria, then in 1951 he established a studio and stoneware kiln at Beecroft in New South Wales. Teaching ceramics since 1952, Peter Rushforth was appointed head of the ceramics section at the National Art School, Sydney, a post he held until he retired in 1978. Since then he has worked as a full time potter at Shipley in the Blue Mountains, west of Sydney. He talks about his work: 'I use the techniques of high fired stoneware as an idiom to express concepts of forms, glaze quality, patterns and textures. As the main method of forming pots I choose to use the potter's wheel as this technique, when used successfully, can offer unique characteristics that are vital and dynamic. Whilst the technique of throwing is often labelled traditional, I find it does not preclude originality and innovation, despite the millenniums of time that the potter's wheel has been in existence. Throwing is, however, only part of the totality of the finished pot. A pot embraces a gambit of techniques, processes and materials all of which are the means through which a potter can express a particular aesthetic and awareness of beauty.'

Peter Rushforth has worked and exhibited in Japan and travelled on a Churchill Fellowship, received in 1967. The *Anagama* style kiln, developed over a long period in the Orient, is one of the kiln types that Peter Rushforth is currently using in his work. 'I am endeavouring to exploit the qualities of fire on clay and the quality of the falling ash from wood-firing. This kiln I fire for five or six days and the ash falling on the pots forms a natural glaze. In another wood-firing kiln I have been developing for some years a *Chun* blue glaze. The wood fire seems to give the glaze a deep opalescent blue that I have not been able to achieve in other fuel kilns.'

Living with vistas of valleys, bushland and mountain escarpments possibly influences Peter Rushforth's choice of colours and textures. However, as he says: 'Dominating my pots are the processes themselves, fire, clay and the earth materials that form the essence of individually made pots.'

In an article entitled *Twenty-Five Years*, written by Peter Rushforth, he had this to say: 'Our knowledge of technique has grown enormously, but if our craft education and our own work does not extend beyond technique, then I think we have missed the point of what the craft movement is about in this technological

8 See *Pottery in Australia*, Vol. 20/2, 1981

Eileen Keys, plate, earthenware, glazed over poured cobalt, nickel and copper slips, 2.5 x 23 x 23 cm, 1986. Collection of the Art Gallery of Western Australia

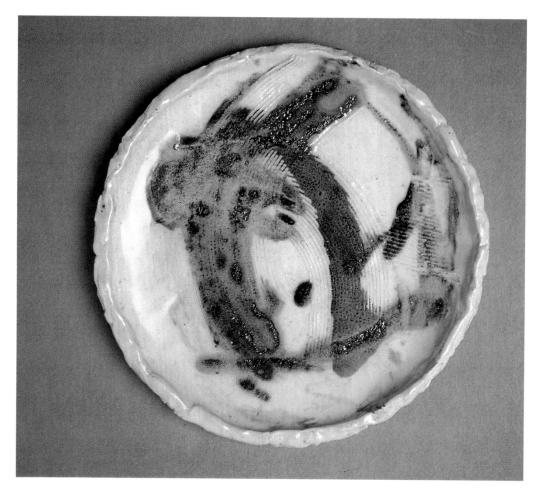

age. To me it is an expression of the human spirit, it must communicate aesthetic values, human values and not mechanical values. It is an art of the people and not a precious activity for a chosen few. I think it is in danger of becoming sterile if it is intellectualised and, above all, the art of the potter is concerned with making objects for daily use. This is what I have been striving for in my own work during the last twenty-five years.'[8]

In 1985 Peter Rushforth was awarded the Order of Australia for his services to pottery. From the catalogue of the retrospective exhibition of Peter Rushforth's ceramics, held at the National Gallery of Victoria, in December 1985, Kenneth Hood wrote: '. . . Rushforth believes that anyone now making stoneware must use techniques that invariably can be traced back to the Orient. After his direct contact with Japanese potters and traditions, Rushforth's pots became freer and more spontaneous. The infiltration of this Japanese influence into Peter Rushforth's pottery has been gentle, colouring his later work in an elusive way. The progression from one period to the next is unobtrusive but the later pots have now what Bernard Leach has called *nonchalance*. This does not imply any lack of concern for the finished pot or laziness, but rather an acceptance of the irregularities that can occur in the clay and the kiln. Rushforth's first pots had a classic simplicity and purity of shape. . . his latest pots take on a life and spirit far removed from smooth perfection, and his love of nature has given him an affinity with the the inherent qualities of clay and the direct action of the flame.'

In contrast, both in philosophy and technique, is the individual approach of Eileen Keys. She believes herself to be not a traditional potter but an artist with an intense experimental interest in the effects of minerals and rocks. Born in Christ-

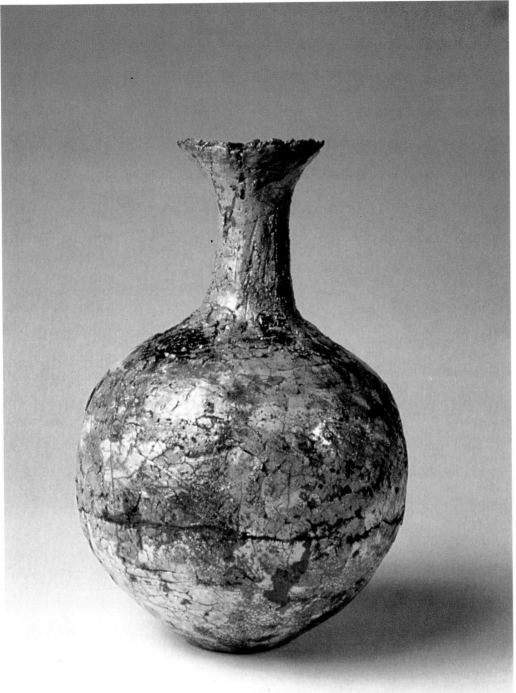

Milton Moon, landscape bowl, stoneware, 40cm/d

(left) Eileen Keys, vase earthenware with nickel ore in clay, 32.5 x 22 cm, 1973. Collection of the Art Gallery of Western Australia

church, New Zealand, where she attended Art School and Teachers College in the Montessori method, in 1939 she studied at the Chelsea Art School in London and undertook some pottery courses with an Adult Education programme. In 1947 she moved to Western Australia where her husband became the Principal of Scotch College, Perth. Eileen Keys gave pottery classes at the College, and with no materials commercially available to her, set about gathering and testing all the clays, rocks and ashes she could find.

This use of the local materials and her investigations for their unique qualities has been a feature of Eileen Keys' work. Robert Bell, Curator of Craft of the Art Gallery of Western Australia writes 'A trip to England in 1970, after meeting Bernard

9 *Eileen Keys, Ceramics 1950-1986*, a catalogue published to commemorate her Retrospective Exhibition, Art Gallery of Western Australia, 1986

Leach and reading his *A Potters' Book* only strengthened her resolve to develop ceramics solely based on an Australian sensibility and using locally available materials as the only source of colour and decoration in her work.'[9] She collected clays and minerals from mining sites in the Hammersley Ranges, at Kalgoolie and at Coolgardie and undertook years of experimentation for colour and surface effects, learning the melting points of the minerals she collected, examining the effects of these materials when they were mixed into the clay either separately or in combination. Robert Bell again: 'Eileen Keys has been an important figure in pottery for the last 30 years. Her style and attitude to her work have influenced a lot of people, including me. She has remained constant and true to her beliefs about making ceramics. She pioneered working with Western Australian clays and minerals and was the first to make studio stoneware in the West. She has remained consistently innovative, even at 83 years of age, she is doing new things.'[10]

Just as Eileen Keys' attitude is unique, so is the expression of her work in clay. Forms are simple, original and sculptural, they are like the rocks from which they were made. 'I do not call myself a potter as potters are today,' she says, 'they are interested in what they throw or what they do. I have always been interested in what the materials did.' Her work has been collected by the major art galleries of Australia, recognising the contribution and influence this potter has had on many ceramic artists in Australia. Joan Campbell wrote about Eileen Keys in 1969: 'Even the remote ridges of Rum Jungle where she sought the elusive uranium ores and the heights of the Hammersley Ranges for cobalt and copper have known her exploratory feet, as she endeavoured to gather her materials from their natural setting. She researched these materials for eight years to achieve the rich glazes which complement her rugged, blunt, direct pots and sculpture. A range of ash glazes derived from the leaves of lemon-scented gum, sandalwood, banksia, karri, pine and seaweed were developed. She enlisted the assistance of local geologists in finding and unearthing rocks with high concentrations of desired minerals, gradually eradicating high iron bearing rocks from her working materials in preference for uranium bearing ores.'[11] Eileen Keys says, 'The knowledge of the fluxing nature of the various ashes enabled me to combine them with the rocks to formulate rock glazes. I feel Western Australia's explosive mineral development has given me a wonderful chance to find a fresh approach, a new kind of beauty in the country around me.'

Purposes of scale, pure form and presence are evident in the work of Marea Gazzard. She studied ceramics at the National Art School, East Sydney and then at the Central School of Arts and Crafts in London, finishing there in 1958. After travelling and living overseas she returned to Australia in 1960 to establish her workshop. Since that time she has exhibited work in clay and metal.

For the catalogue of *Recent Ceramics,* an exhibition of Australian ceramics that toured overseas in 1980-81, Marea Gazzard wrote: 'I work in a large scale in ceramics and to do this I choose the coiling method. My particular interest is in three dimensional shapes that help form a particular environment. This is why my work becomes more sculptural than pot.'

Marea Gazzard likes to work in a series, placing groups of objects together which are variations and developments on a theme. One series of work, taking three years to evolve, the *Uluru Series,* represented her interpretation of the Aboriginal Dreamtime mythology associated with the rock monoliths of the area around Ayres Rock and the Olgas in Central Australia. Her current work is in bronze, mostly for public commissions.

Awarded the Order of Australia for her contribution to the arts, Marea Gazzard

10 Anne Burns, quoting Robert Bell, writing for The Western Mail Magazine, 1986

11 See *Pottery in Australia*, Vol. 8/2, 1969

Milton Moon, landscape platter,
Stoneware, 52 cm/d

is known nationally and internationally for her work for the craft movement. Her appointments include the President of the World Crafts Council, and Chairwoman of the Crafts Board of the Australia Council.

The two strongest influences on ceramics in Queensland in the 1950s were Milton Moon and Carl McConnell, both of whom were responsible for setting a standard and fostering a continuing interest in pottery as a vocation. Their contribution to the growth of ceramics in Australia is recognised nationally. McConnell stayed to continue his teaching and exhibiting in Queensland, and was honoured by a retrospective exhibition of his ceramics at the Queensland Art Gallery in 1986.

Milton Moon moved from Brisbane to Adelaide in 1969. He set up his pottery in Summertown in the Adelaide Hills of South Australia in a nineteenth century stone building after a teaching career both in Queensland, for the Queensland Department of Technical Education, and in South Australia, where he taught at the South Australian School of Art between 1969 and 1975. He was first introduced to pottery by Mervyn Feeney, a traditional potter working in Brisbane. Milton Moon's awards for his work include a Churchill Fellowship and a Myer Foundation Geijutsu Fellowship, both of which enabled him to travel and study overseas. In 1984 he was awarded the Order of Australia.

Dr Lloyd Rees, opening Milton Moon's exhibition at the Potters' Gallery, Sydney in June, 1985 had this to say: 'Milton Moon has been one of our basic potters. His forms are never academically repetitive. He extends the language of basic form but never gets out of reach of it. You feel only an Australian potter would have produced the pots. He has played with the surfaces to get something of the nature of Australian life but never done it falsely. Just enough to suggest it without being destructive to the form. Pottery is a disciplined art form, but potters should not become rigid in their craft... I always look upon art as a way of life and I find working to a theory always holds the seeds of decay. Good art should be done for its own sake without worrying if it is going to survive or not. If in the process you have got down to something basic, something that vibrates as it were, it may live on into the future. Milton Moon's pots have a sense of our time and a relationship towards place.'[12]

12 See *Pottery in Australia*, Review section, Vol. 24/4 1985

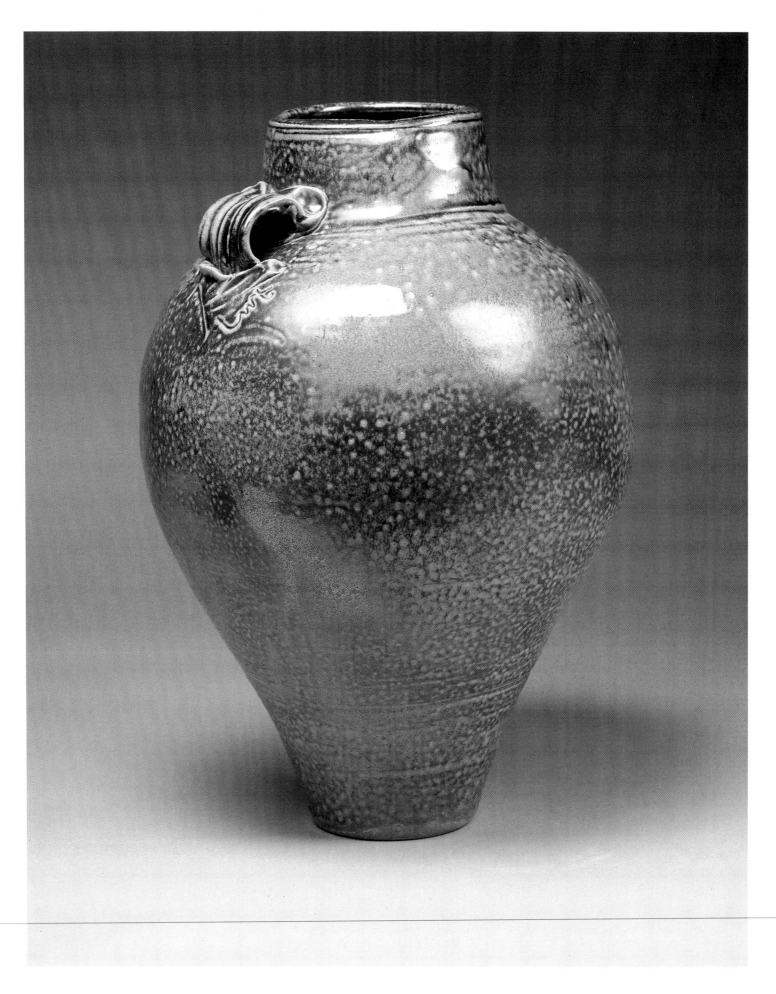

2

GENUINE EXAMPLES OF
THE POTTER'S ART

The ambitions of Australian potters cover a range of ideologies: from those who enjoy the rhythm of the production run to those who seek satisfaction in the individual object; from those whose work comes out of the discipline of the wheel to those who seek freedom from adherence to traditional techniques; from those who seek simplicity of form and decoration in which the identity of the maker is not dominant to those who seek a strong self-expression in highly individual styles and ornamentation. All are genuine examples of the potter's art.

Of significant influence on the development of Australian pottery in the 1960s was the British craft movement with its dominant figures of Bernard Leach, Michael Cardew, Lucy Rie and Hans Coper. The philosophy espoused by Leach called for pottery made with spirit, a concern for beauty and the commitment of the whole person. Leach believed in the unity of life and in 'making things for full human use – objects which are projections of man – alive in themselves.'[1] This hand-made pottery, as in the best folk traditions, was meant to serve everyday needs and play a vital role enriching the community for which it was made. This philosophy also was a reaction to large scale manufacture and attempted to re-establish a more humanising scale of local industry. Michael Cardew, Leach's first student, added to this philosophy a commitment to standards; no category of pot was superior to another with no division being made between routine production and individual pots. At the same time, the work of Lucie Rie and Hans Coper exerted a strong influence on the British craft movement. Stemming from the Modernist movement, Rie and Coper provided the craft aesthetic with a formal understanding of proportion, precise form, and sharp outline.

Gwyn Hanssen Pigott's work reaffirms the vital role of traditional hand thrown domestic ware. Her work aspires to an Oriental ideal of apparent ease of execution. Out of the discipline of repetitive work comes a lyricism and ease. Craftsmanship is shown in an unfaltering care and attention to subtleties of form and decoration. This is how functional ware transcends pure function and has living elegance. She writes: 'My background in ceramics has been firmly rooted in the British crafts movement fathered by Bernard Leach and Michael Cardew, and illuminated by such stars as Hans Coper and Lucie Rie. After completing a Fine Arts degree at Melbourne University, I was apprenticed for three years with Ivan McMeekin, a Sinophile and a student and friend of Michael Cardew. From him, at the workshop he founded at the Sturt Craft Centre, Mittagong, I learned to understand and

Janet Mansfield, salt glazed jar, iron slip and ash decoration 45 cm/h, 1986

1 *A Potter's Book* by Bernard Leach, Faber and Faber, 1940

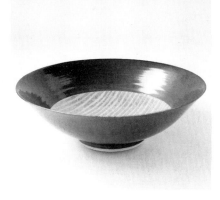

(*top*) Gwyn Hanssen Pigott, bowl

Gwyn Hanssen Pigott, bowl, lustre decoration

appreciate more fully the qualities inherent in the Sung Dynasty Chinese ware which had first inspired me to become a potter. My work with him, my time with Cardew and Leach, my life in London exposed to the works of Rie and Coper and Shoji Hamada, the museums of London, Oxford and Cambridge, and then seven years working and living among the wood firing potters of Haut-Berry in central France, form the ceramic background to my work in Australia today.

'Presently I am working with porcelain and a wood firing kiln, although at any point that could change as it has in the past. I am concerned in my work with a sort of beauty that has little to do with the clay, kiln or glaze that I use, per se. Sometimes I feel my concern is an obsession with permanent life, the eternal contradiction. As I want my work to feel timeless (the reality is only proven over time) my references are mainly historical. My pots are thrown and only occasionally altered from the round, and yet my concern is primarily with form, and with muted colour, and quietly repetitive patterns, teetering on the verge of the mechanical, or nothing.

'Sometimes a great deal of effort and complication is behind my obsession with effortlessness and artlessness. It might be hours of making the same stroke which almost disappears into the glaze, and from even a short distance merges into a wash of colour. Or stoking the kiln for hours with wood just to get a fine film of ash on the semi-protected piece, to change the colour of the glazes subtly, or to enliven an otherwise totally simple form. Or the pot may simply stand, gas fired, undecorated on the quality of form and glaze alone. My present heroes are Hans Coper, the English ceramist Elizabeth Fritsch, Lucie Rie, the painter Morandi, the sculptor Brancusi but the repetitive nature of my decoration is somewhat of a homage, a link with the humanising power of traditional craftspeople; the weaver, embroiderer, basket maker, knitter; as if time spent on the work can hold time somehow and call us to stop.'[2]

Peta Collins wrote in 1977. 'Unlike many other Australian studio potters, whose work is taking on more decorative and sculptural attributes, Gwyn Pigott considers the important role of the potter is to produce utensils which enhance our day to day existence. Her soundly made domestic ware reflects a refinement of style and testifies to the strength of traditional functional pottery'.[3] Peter Haynes, reviewing *The Delicate Touch II* Exhibition at the Narek Gallery, said: '. . . the work is characterised by a simple structural elegance. The surfaces are full of subtle contrasts, the colours understatedly fine. Her forms are traditionally simple and the innate honesty of her understanding of the necessity of the resolution of surface and form gives her work both strength and beauty.'[4]

The commitment to making pots, and many of them, the rhythm and flow of a run of pots from the wheel, the attention to every aspect of the decoration and finish, the wholehearted approach to what one is doing, characterises the work of Les Blakebrough.

Les Blakebrough has made a significant contribution to the development of Australian studio ceramics. Currently working in Hobart, where he runs a professional workshop, he continues to influence others by his teaching, his exhibition programme and in the training of apprentice potters. Les Blakebrough had his initial training in ceramics at the East Sydney Technical College between 1955 and 1957. From there he became apprenticed for two years to Ivan McMeekin at the Sturt Pottery, Mittagong. A further two years were spent studying in Japan with Takeichi Kawai after which he returned to Australia to become the Director of the Sturt Craft Centre. It was 1973 when Les Blakebrough moved to Tasmania to continue his teaching and exhibition work.

2 See *Pottery in Australia*, Vol. 22/1 for an extensive article on Gwyn Hanssen Pigott written by Margaret Tuckson

3 *Seven Tasmanian Potters* by Peta Collins in *Pottery in Australia*, Vol. 16/1

4 Peter Haynes, *The Canberra Times*, June 1985

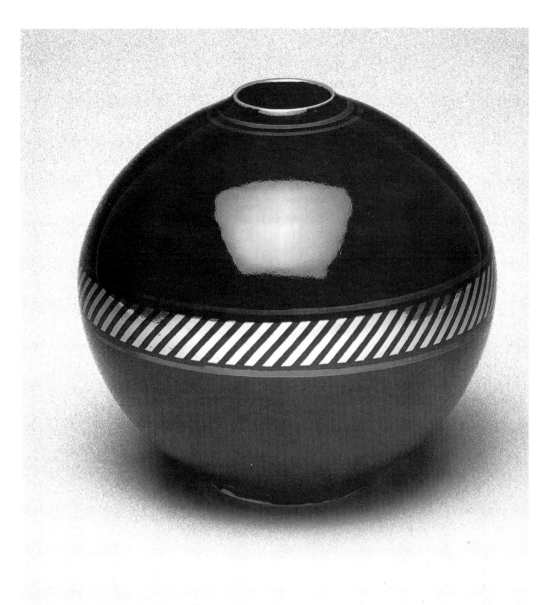

Les Blakebrough, sphere, black glaze, gold lustre, 15 cm/h

A true professional, Les Blakebrough has always been concerned with standards, not only for himself but demanding a commitment from his students and apprentices and working both himself and them to the fullest. 'I have been fortunate in discovering something to do that I have always found intensely interesting. I had a curiosity about the phenomena of clay and fire, of using a material that required skill and dexterity as well as to try to translate ideas created in the mind's eye. As this is such a long and complicated process, I rarely tire of the demand it imposes. Occasionally I expect the process overall to become less demanding, to become easier, but it never does. From creating a plastic material that is a pleasure to use to the entirely different skill of controlling fire and working with it, my expectations continue to extend. At present I am working with unglazed porcelain, using the glazes as decoration, and also glazed forms that I decorate with gold and platinum lustres; so my work is quite varied in its scope.

'The way pots look is important to me' says Blakebrough, 'and I strive for my own ideas of perfection, either in the detail of how a small porcelain box is made or how a large sphere stands with a strong form and bold decoration. I enjoy handsome pots that have their own presence. Having said that, other things remain equally important aspects of my work. There is the day to day business of putting the pots

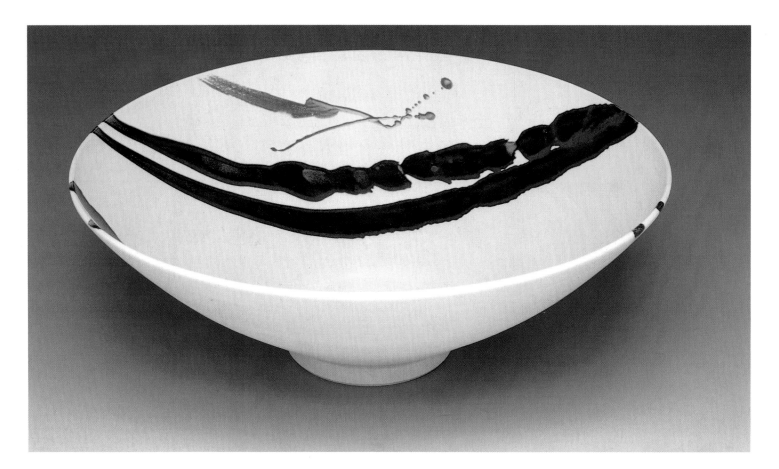

Les Blakebrough, bowl, unglazed porcelain, glazed decoration

together, the quality of my surroundings, and the other people I have around me. All these aspects go together to make up my day's work and hopefully go towards making a relaxed and pleasant atmosphere. If the workshop is tuned up that way there is a better chance for the completed work to be good.'

Jill Stowell reviewing Les Blakebrough's exhibition at the Cook's Hill Gallery, September 1985, talks of Blakebrough's continuing commitment to domestic and functional forms such as the dinner services, tea services and plates. She also wrote of his emphasis on the sphere and its use as an ideal form for storage jars and vessels and as a vehicle for decoration. She sums up 'It was a wonderful demonstration of classical control of materials and meticulous decorative invention.'[5]

In addition to his pottery, Les Blakebrough has undertaken a number of commissions for architects. In 1977, Peta Collins wrote: 'Les Blakebrough's work shows sculptural tendencies. He often finds a need to work on a larger scale from the restrictions imposed by wheelthrown work, and is interested in large architectural pieces. There is a preoccupation with scale behind his work, a concern for monumentality, yet not dictated by size. He has said "When scale is controlled in this manner it becomes a limitless concept".'[6]

A similar enjoyment of all aspects of the potter's art is evinced by Victor Greenaway. Victor Greenaway has been a full time potter for over 16 years. In 1967 he received his Diploma of Art from the Royal Melbourne Institute of Technology and then completed a traineeship with Ian Sprague at the Mungeribar Pottery in Upper Beaconsfield, 50 kilometres from Melbourne. After an extensive study trip in 1974 as a Winston Churchill Fellow he established the Broomhill Pottery, also in Upper Beaconsfield. Since that time he has had frequent exhibitions, established many outlets for his work, trained a number of apprentices and has received much acknowledgement for the style and quality of his work. Victor Greenaway's pottery

5 See *Pottery in Australia*, Vol. 24/4, 1985

6 *Seven Tasmanian Potters* by Peta Collins, *Pottery in Australia*, Vol. 16/1, 1977

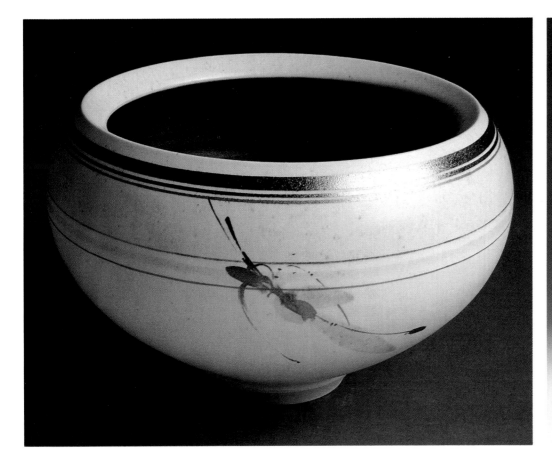

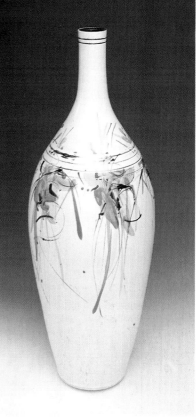

continues to be refined with a purity of form and lively fluency in the brushwork. The forms and the decoration show a confidence and a discipline gained from many years in the production side of the pottery.

In an exhibition in 1976, at the Narek Galleries in Canberra, Victor Greenaway showed both figure forms and functional ware. W. S. Ramson reviewed the work thus: 'The figures and the new compositive pieces which use them, indicate the directions of Greenway's thought, the tensions between craftsman and thinker. There is the stock of the domestic potter but no recognition of the limitations commonly accepted by the domestic potter. With the energy of reappraisal, they do not conform. His pottery offers the harmony which his larger, more intellectually exploratory forms suggest; they recognise the same validity and, on the simply decorative level, beauty. These are the precious things with which we surround ourselves.'

Teaching and exhibiting ceramics since his arrival in Australia in 1956 from England, Derek Smith has been producing a distinctive range of domestic wares and exhibition pieces for galleries throughout Australia. In 1973, he established a studio within the Doulton ceramic factory. He wrote at that time: 'The idea of a closer relationship between the ceramic industry and the hand craftsman was something that had been with me since my days as a student, instigated by study trips to the potteries at Stoke (including Royal Doulton) and the obvious differences in attitude between the craft potter and the large scale manufacturer.'[7] Here, with skilled assistants, he was able to produce a range of domestic stoneware pieces in quantity and a smaller amount of exhibition pieces as well as limited editions showing variations on a theme.

Peter Rushforth, in a critical review of the work of Derek Smith exhibited at the Potters' Gallery in June 1975, wrote: 'In the dichotomy of values amongst many

(left) Victor Greenaway, bowl, matt black interior, lustre and cobalt decoration, 28 cm/d

Victor Greenaway, tall bottle, matt glaze, bushwork in underglaze stains and lustre, 48 cm/h

7 *The Royal Doulton Studio Pottery in Australia,* by Derek Smith. *Pottery in Australia,* Vol. 13/2, 1974

8 *Derek Smith and Doultons,* review by Peter Rushforth, *Pottery in Australia* Vol. 14/2, 1975

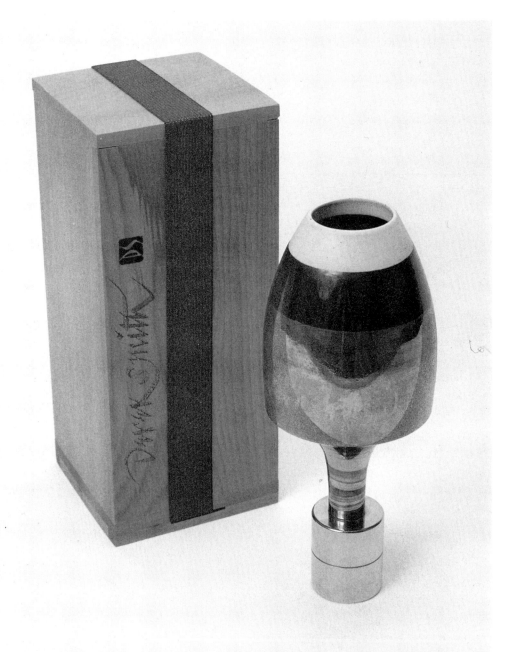

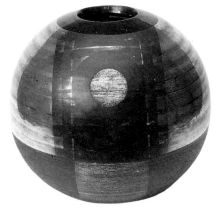

Derek Smith, stoneware sphere, black glaze and liquid gold, 34 cm/d

(above, right) Derek Smith, porcelain stemmed form, nickel base, black glaze and liquid platinum, 19cm/h

potters, whereby some approach their work with an intuitive or abstract expressionist manner, working directly with their materials, others approach their work more consciously, designing with an architectural concept of planning, Derek Smith would come closer to the latter group and his training as a designer has well fitted him to accept the challenge of establishing a studio workshop in relation to an industrial plant. The impact of the exhibition is that of sophistication and contemporary values. It is well and truly implanted in our present age; there is no nostalgic yearning for the qualities of a Medieval jug, a Sung jar or a Koetsu bowl. The style seems to stem from the basic forms of Cubism; cylinders, cubes, cones and spheres, with most forms stripped of unnecessary details in the same way that Brancusi treated his sculpture earlier in the century. Within this framework, Derek Smith has chosen a low key pallette of ceramic colours... In his work there is meticulous attention to every detail, proportions are carefully related, rims, bases and endings of pots are designed with exactitude and precision, there is no fumbling in these pots with each movement of the form well articulated...'[8]

Leaving Doultons in 1976 Derek Smith set up his own studio, Blackfriars, in Chippendale, an inner Sydney suburb to continue his work as a studio potter. He closed this in 1984 to set up a studio in Tasmania where he had lived and worked in the 1960s. Derek Smith's first exhibition on his return to Tasmania, held at the Handmark Gallery in November, 1985, was enthusiastically reviewed by Paul Boam for *The Mercury,* Hobart: 'The works exude maturity, sensibility and skill. They make all the fatuous arguments about art and craft seem totally valueless. They are timeless...'[9]

'A genuine expression of life' is how Bernard Leach referred to a good pot.[10] 'It implies sincerity on the part of the potter and truth in the conception and execution of the work.' In her own work this author has been influenced by the Leach philosophy and cannot read his words and ideas without saying, 'Yes, I concur with that approach. I will seek beauty and usefulness in my work and try to make worthwhile pots that people can enjoy and be enriched by in daily use.' This approach is still a guiding light for me after twenty five years as a potter and I can foresee a lifetime of self-fulfilment in the striving. To make pottery that reflects the best in one's character and one's culture, working in sympathy with materials and skills, understanding the fire and ever seeking to discover new aspects of the art of the potter, seems to me a worthwhile goal of work and life.

Over the last twelve years I have concentrated on the techniques of salt glazing, finding in that aesthetic, scope for self-expression, for historical research and for experimentation into new ways. Using the clay and other minerals from the Gulgong area in central western New South Wales, firing the wood kilns that I have built in Gulgong, I hope to turn the processes of my work into an aesthetic statement. As the salt glaze accentuates the marks made on the clay and the ash from the firing enriches the salt glazed surface, the forms of the work become a dominant issue, all part of the process. Function is but one aspect of the pottery that I make.

At an exhibition at the Green Gallery in Tokyo, Japan in 1985, Amaury St. Giles reviewed the work: 'Drawing on the lengthy world history of ceramics Janet Mansfield ably captures the gracefulness of ancient oil and wine vessels, amphorae, in her larger works. Add the burnished subtlety of salt-glazing and you have an outstanding example of her potting expertise. The exhibition works range from small cups to large and commanding vessels but her strength is surely found in the russet and beige glazing that makes each piece so visually striking.'[11]

Being a full time potter means making considerable demands on oneself, believes Greg Daly, 'pushing oneself further and further. To keep extending one's ideas, keep those ideas developing and changing and pushing techniques to create ideas. However,' he says, 'no technique will make a pot live, it is the character and spirit of the potter that will give a pot real beauty.'

Greg Daly established the Marra Pottery in 1975 not long after receiving his Diploma of Art from the Royal Melbourne Institute of Technology. The following year he received his Fellowship Diploma from the same Institute. Since that time his work has continued to evolve, using a variety of techniques, surface finishes and scale. Now he is represented in many collections, both national and international, and is a member of professional associations of ceramists world-wide. For ten years, Greg Daly has been perfecting a particular organic form, making some to one metre high in stoneware, slip casting similar shapes in bone china and using a variety of surfaces. Lately these have been glazed in a shiny black lustre and mounted on perspex boxes to stabilise their tiny bases. The platter form is also synonymous with Greg Daly's work. He says: 'Platters provide me with a surface on which to develop

Janet Mansfield, flower vase, salt glazed, 30 cm/h 1987

9 See *Pottery in Australia,* Vol. 25/2, 1986

10 *A Potter's Book* by Bernard Leach, Faber and Faber, 1940

11 Amaury St. Giles writing in *The Mainichi Times,* Tokyo, August, 1985

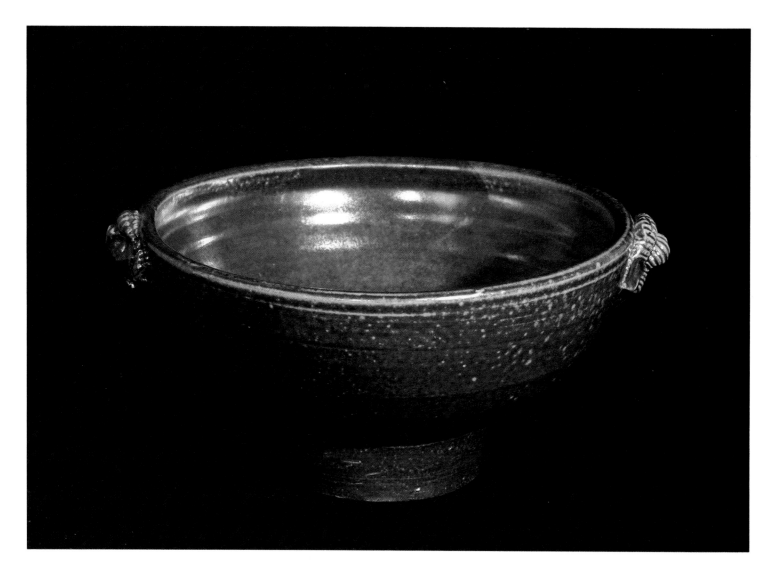

Janet Mansfield bowl, salt glazed, wood fired, 25 cm/d, 1987

glaze effects and depth, creating abstract images drawn from the effects of light, water reflections and atmospheric conditions of sky and rippling water, fleeting colours and impressions glimpsed. I have also been working with 23 carat gold and silver leaf as well as coloured enamels to further create these surface effects and illusions.'

Greg Daly's exhibition at Cook's Hill Galleries, 1982, was reviewed by Helen Whittle: 'Thrown bowls and plates caught fragments of an intangible landscape held there with a skilful use of glaze. He is very much at ease . . . there is a flow and unity to the show.'[12]

Rhythm, balance, texture, form and the struggle to achieve harmony within the total experience. With these words, Joan Campbell likens pottery to poetry. Well known throughout Australia for her community work for craftspeople, Joan Campbell is equally well known for *Raku* ceramics. Many awards and commissions have been granted to Joan Campbell since she commenced pottery making in 1960. She describes her life and her work: 'As an Australian with no tradition in ceramics I long ago wondered what taproot would give a base from which my work with clay and fire could spring. Here on the western side of Australia, where the winds sweep up from the Indian Ocean weathering the limestone coastal plain, reforming the terrain, where the light bleaches out the colours to muted greys and blues, I became acutely aware of the influence of these forces on the land. Today these elements find reflection and reinterpretation in my work with clay and fire.

12 See *Pottery in Australia* Vol. 22/1, 1982

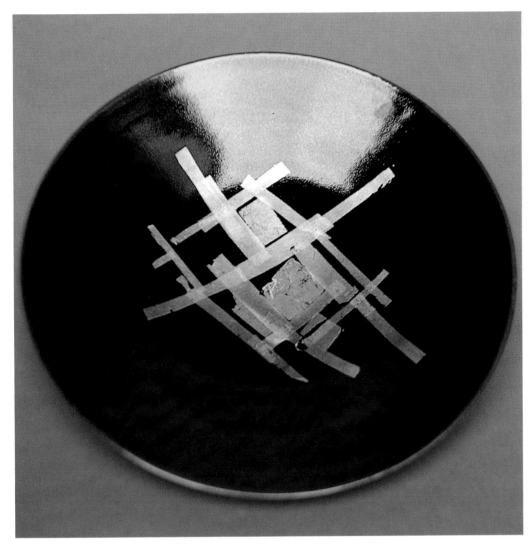

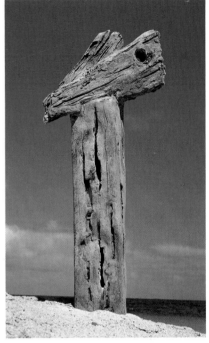

Joan Campbell, *Raku* form

(left) Greg Daly, bowl, silver and gold leaf, 35cm/d

'I build predominantly by coiling clay, using wheel thrown sections to extend the forms. These forms are mostly asymmetric, the challenge being to achieve on completion a balance, still but moving. The scale of my work varies with free standing sculptures ranging from 45 centimeters to 2 meters or more. The wheel thrown pebble forms that I use as a base for many compositions are fired, stacked bonfire fashion with seaweeds in the kiln. My workshop, right on the beach at Fremantle, is well placed to gather a variety of seaweeds which result in vivid flashings on the pebble forms. I rarely use glaze, preferring to wash colouring oxides or a liquid clay slip over the pieces to accentuate the textures and give subtlety of colour. I have also been doing some figurative pieces on commission for placement in gardens. My work is born of the time and place of its making, witnessing the wonders of the western side of this continent. Over many years I have evolved methods of making forms and firing that hopefully express the adventure of making, the force of the fire and the flow of life.'

After a Raku seminar given in Melbourne by Joan Campbell in 1971, Connie Dridan reported: 'Her sculptural pieces expressed her appreciation for qualities of the landscape, the intense clarity of light of the western coast, the tonal values of land and seascape. A visit to remote southern parts of the west coast was an inspiration for her work and for increase in scale... She believes *Raku* is soft and fragile, though born of ability to resist violence and shock. The means of her expression is appropriate to the meaning of her works; the process of *Raku* is fitting

13 *Report on Raku Seminar* by Connie Dridan, *Pottery in Australia*, Vol. 10/2, 1971

Joan Campbell, earthenware form

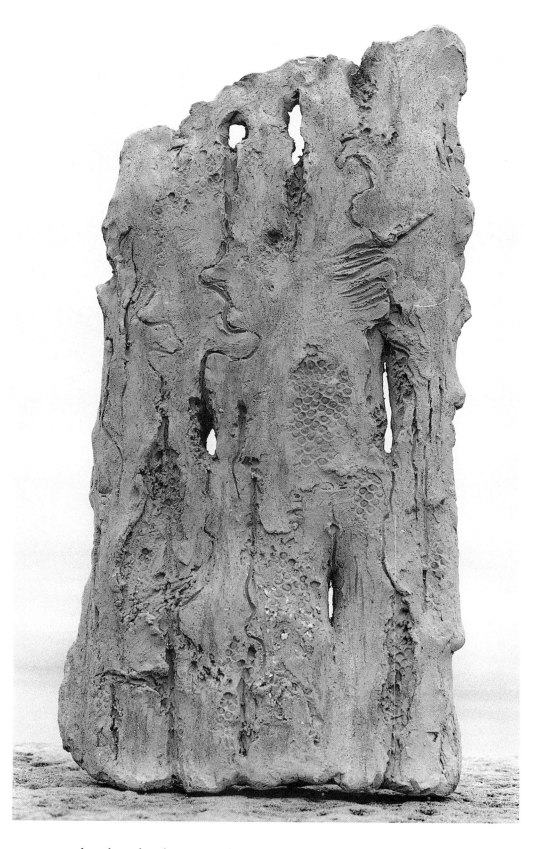

to express the idea of endurance in both the landscape and the human spirit.'[13]

In an article on Joan Campbell, Ian Templeman wrote about her working methods in 1972: 'In primitive potting conditions she likes to work dangerously, daring the barely controlled creative accident to happen... struggling with the delicate balance between... her personality and the nature of the material...'[14] Templeman contrasted the spontaneity with the control in her work. Her closeness

14 *Joan Campbell* by Ian Templeman, *Pottery in Australia*, Vol. 11/2, 1972

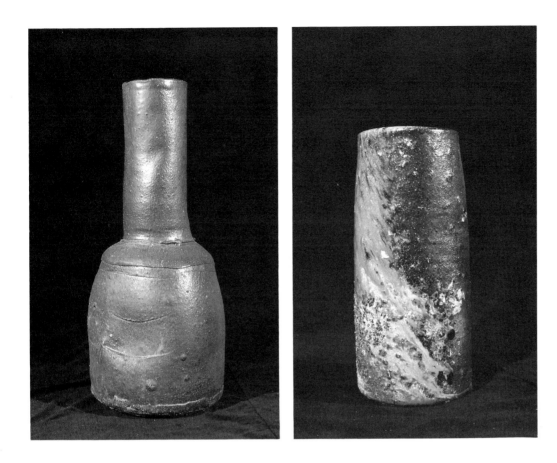

(left) Owen Rye, *Anagama* fired, 52cm/h

Owen Rye Cylinder, Fired in *Bizen* style kiln using willow ash, 25cm/h

to her materials and processes, the clay and fire show the dialogue between maker and material.

Craftsmanship is important to Joan Campbell. She says: 'Craftsmanship is caring, it is caring with the hands, feet, eyes, mind, the whole of the body and it is caring about the foot, the lip, the handle, the mechanics of the wheel, the burners, the mixers, but it is more than all these, it is caring about life.'

Owen Rye studied with Ivan McMeekin while gaining a Bachelor of Science degree from the University of New South Wales. In 1970 he gained a Ph.D. for his technical studies of porcelain. Travelling, teaching, working with and studying traditional potters from many cultures, writing books and gaining awards are all part of Owen Rye's life.[15]

Owen Rye works in two areas of ceramics, both of which refer to the art of the potter. 'In one' he says, 'I do what I was originally trained to do, make useful objects which people find attractive, and wish to use for eating, drinking and serving food each day. My other work is aimed at achieving a complex and varied surface colour and texture, on increasingly simple forms, and decorated by simple marks on the clay while it is still soft. The firing process for this work is an important part of the process; saggar firing, wood firing and more recently wood fired salt glaze have been used to enrich the surface. Slips and glazes are sometimes used for extra variations. The final result to my eye is abstract and suggestive of natural events, processes and features – mudcracks, volcanic flows, patterns of light in foliage, fire blackened landscapes, pebbles beneath clear water, thunder clouds and red earth – natural phenomena and man-made scars all far removed from the urban concerns which motivate many Australian clay workers. The landscape which I have absorbed is Australian and more likely to be harsh and abrasive than soft and romantic and the risks of my firing processes are evident in the finished work. The pieces that survive are often unique.'

15 *Owen Rye*, by Norman Creighton, *Pottery in Australia*, Vol. 24/4, 1985

3

IMAGERY OF TIME & PLACE

Ceramics is related to history and much can be learnt of ancient cultures from the ceramic works they left behind. Potters working in Australia today reflect in their work something of today's culture. For some ceramists, however, this conscious mirrorism of social history is one of the driving forces behind their creativity.

A feeling for contemporary Australian urban history, combined with the challenge of technical processes, is characteristic of the work of Michael Keighery. The variety and presence of pots reveal, for him, aspects of different times and cultures. 'Pots,' he says, 'have been items of beauty and utility, they have been surfaces for patterning and storytelling. Ceramic works have always told stories and in Australia, at the end of the twentieth century, the substance of these stories will be different from the stories of other times and places. To conceive and convey stories and ideas relevant to the present day is very important to me. Almost invariably though, this sets up a tension between the seductive influences of historic ceramic expressions and the personal need to relate to contemporary society.'

Michael Keighery graduated with a Bachelor of Arts (Visual Arts) from the Sydney College of the Arts. He is currently undertaking some post-graduate research at the same college and also teaching there. Keighery finds the processes of working the clay 'a powerful force. Being able to mark the clay directly, the physical manipulation of the materials and the excitement, power and risk of the fire are all aspects of the ceramic processes that I enjoy.' Peter Emmett, writing about Keighery in an article, *Sydney's Burning, Fire! Fire!* comments: 'I keep returning to the word *process* to understand Keighery and his work. The artist is inevitably part of his immediate world. His works capture the very process of human interaction with the environment; a rawness and energy juxtaposed with an engineered precision. A brutal, vertical shape like a pylon emerging from the foreshore abruptly meets a fragile section of porcelain surfaced like the ripples of the shoreline. Sounds romantic but in fact it jars the perception like the realities of the jarring processes of technology and nature.'[1]

However much Michael Keighery enjoys the processes it is the finished piece that has the most importance to him. 'That is, making ceramic pieces that enable me to express aspects of my physical and psychological world. The transformations of materials, the urban environment and the deliberate interrelation of shapes,

Michael Keighery, vessel, extruded and assembled, blackfired. 50cm/h, 1986

Michael Keighery, vessel form, coiled, blackfired, 95cm/h, 1986

1 See *Pottery in Australia*, Vol. 26/1, 1987

Rod Bamford, *Croyden Excavation Site. Lusher Road,* 1985, Ceramic, 68 x 88 x 26 cm

surfaces and materials around Sydney are the strongest visual influences on my work. The buildings, industrial working sites, the forms and textures of this city hold my attention and provide a metaphor for many aspects of my life.' Carl Andrew has written in a review of the Mayfair Ceramic Award Show, 1984: 'Michael Keighery's contribution to this exhibition marks him as one of Australia's most intelligent and sensitive artists in the medium of clay. His six *Reference* pieces use precise squares of papery cast bone-china against freely manipulated black-fired clay panels to explore his contemplative response to urban and rural landscape. The totemic *Figures* combines a range of techniques and materials to achieve articulated and integrated forms of great presence.'[2]

'Keighery's work is technically excellent,' wrote Judith Woodfall for *The Age,* reviewing his exhibition at Devise Gallery in 1986. 'It is innovative, restrained and sophisticated. His use of colour is subtle... the best of his art is seen in his wall pieces. They are masterpieces.'[3]

Rod Bamford is a ceramist for whom the perception of history is significant. Rod Bamford makes works which draw from his experience as a potter and his studies of studio pottery. However he says he shrinks from the term *potter* or *pot,* not because of the activity but because of the stereotyped image and connotations of the particular values and lifestyle normally associated with such terms. 'In a broader area, a similar stereotype separates *art* from craft. Although I understand that categorisation is a useful tool for collective understanding, to make sense of things,

2 See *Pottery in Australia,* Vol. 23/2, 1984

3 Review by Judith Woodfall, *The Age,* August, 1986

Alan Peascod, *Jar with Mythical Bird*
matt orange glaze, 36 cm/h, 1980

(left) Rod Bamford, *Fragment Qf 26/3,
Razy* Site, 41 x 60 x 12 cm, 1987

my ceramic works are concerned with the notions deliberately made to avoid these categories. Undoubtedly though, you step out of one box into another. I am not interested in denying the value of the pot. On the contrary, the *shards* that I make stem from my love of earthenware and porcelain and the rich traditions associated with them. The content of the pieces derives from my elations and frustrations with the ceramic process. The forms are fragments and the symbol of the fragment is itself a significant subject for me.' Ross Searle, reviewing Rod Bamford's exhibition, *Ceramic Constructions,* wrote: 'To Rod Bamford, these shards are the fragmentary remains recovered from the demolition sites of our civilisation, a source of imagery providing insights into our society. However the artist is no archaeologist and no attempt is made to order or classify his finds, but rather they recall an era of human experience and memory. Rod Bamford is particularly interested in the destruction and renewal that goes on in our urban environments.'[4]

Rod Bamford wrote in 1985: 'Often the best pieces of a studio potter's work are accidents which occur during the process of making. In searching for the source of these, even broken shards are examined. Over time these have become the subject of obsessive interest for me. The shards have great character... they are pieces of history, fragments of lives. Each one can tell an intriguing story.'[5]

Rod Bamford trained in ceramics at the East Sydney Technical College, gaining his Post Graduate Certificate in 1979, also doing studies in printmaking and bronze casting. After a year in India studying at the Bhadrawati Village Pottery, he

4 *Ceramic Constructions,* Review of Rod Bamford's ceramics, by Ross Searle, for the *Victorian Crafts Magazine,* November, 1984

5 See *Pottery in Australia,* Vol. 24/3, 1985, article by Rod Bamford

Alan Peascod, *Armless and Legless Pot Seller, Cairo*, 32 cm/h, 1982

(right) Alan Peascod, *The Acrobat* (from the series *The Professionals*), 60 x 24 x 13 cm

returned to Australia to complete a Diploma in teaching from the Newcastle College of Advanced Education in 1985.

Kim Martin, writing in 1984 for *The Age* had this to say: 'Rod Bamford is concerned with the bold expressiveness of clay, challenging the natural limitations of the medium to explore its evocative qualities. His sculpture is highly satisfying in terms of form and surface, displaying a great deal of sensitivity in mark making and painting. In a sense, these forms bridge the gap between ceramics and sculpture in a way never before expressed.'[6]

Nola Anderson drew attention to Rod Bamford's awareness of the connection of

6 *Bridging the Ceramic Gap,* article by Kim Martin, for *The Age*, Melbourne, November, 1984

fragments with time, culture and history. She wrote in *Craft Australia*: 'Bamford's ceramics apply a sliding scale to history. Ancient cultural remants, huge, monumental pottery shards, go back in time. Their isolation from a lost world is nostalgic, their mystical value increased by ancient stories. But Bamford also looks at potential history: today's relics, future shards... The shards come from a world of giants. The huge fragmented works have outgrown this pedestrian world and assumed the proportions that history would give them.'[7]

Alan Peascod draws on rich historical sources from South and Central America, Greece and the Middle East for his aesthetic and technical research. He commenced his studies of Islamic ceramics in 1967. He writes: 'As a student of ceramic history I find I have been inspired rather than influenced by strong ceramic expression. This inspiration is an emotional response to work which I perceive as having *content* and a *presence*.' In recent work Alan Peascod has chosen to introduce an element of social commentary, using figurative aspects, to broaden his 'arsenal of ceramic expression. In past years,' he says, 'I have channelled my creative energies into developing ideas which manipulate the more sculptural qualities surrounding the container form.' Planning his work carefully, he says: 'I rarely leave things to chance as I believe it is important to develop a concept with a specific fired finish in mind. All aspects of technique, work practice and concept have a role to play, however I avoid being a slave to technology, developing qualities and taking opportunities throughout the whole ceramic process.'

Alan Peascod's work has been described by Peter Haynes in the catalogue to the the Peascod retrospective exhibition, 1985, as 'one of the most important contributors to ceramic art in Australia' and talks of his research into technology and processes as 'relentless, extensive, dedicated and intensive'. Referring to Peascod's dedication to the arts of Islam which, he says 'has remained a fertile and vital source which manifests itself in his forms and in his treatment of the surfaces of these forms. He is an artist' says Peter Haynes, 'who sifts through his influences... the end product is always a work from Alan Peascod'.

Alan Peascod graduated from East Sydney Technical College in 1965. In 1966 he undertook a year of post graduate training at the Sturt Workshops in Mittagong and in 1972-73 took his in-service teacher training at the Sydney Teachers' College. He was appointed Head of the Ceramics Department of the Canberra School of Art in 1972. Four research scholarships have enabled him to travel and study. A teaching post in England and then Scotland took two years. He returned to Australia in 1986.

'Alan Peascod's whole philosophy' Shirley Moule wrote in 1972, 'derives from his love of rapid action. He likes rapid forms of throwing, rapid forms of glazing and fast firing because he believes that this is the only way to achieve spontaneity. Alan Peascod defines creativity as good craftsmanship and spontaneity, combined with a measure of uncontrolled ingenuity'.[9]

In the innovative areas of colour technology such as for lustre and other glaze surfaces, for forced drying of the work using heat or for his fast firing methods, Alan Peascod has always been a leader. He writes: 'I feel that of any major contribution, the dry glaze territory will probably be my major effort. Probably even more importantly, I feel I have managed to break down community resistance to one-glaze-firing thinking and gain public acceptance to the notion of firing pots as many times as necessary for the effective completion of the work'.[10]

Stephanie Outridge-Field sees a relevance for herself in the role of potter as recorder. She gained a Diploma and a Post Graduate Diploma in Visual Arts from the Sydney College of the Arts graduating in 1980. She comments on her attitude

Stephanie Outridge Field, slab, coloured slip decoration

(*top*) Stephanie Outridge Field, slab, coloured slip decoration

7 *Shards of the Future*, article by Nola Anderson for *Craft Australia*, Summer, 1985/4

8 See *Pottery in Australia*, Vol. 24/3, 1985

9 *Alan Peascod* by Shirley Moule, *Pottery in Australia*, Vol. 11/1, 1972

10 Catalogue to the *Alan Peascod Retrospective* Exhibition

John Odgers, *Monument to Human Folly*, 30 x25 cm, 1986

to her work: 'I feel challenged by the versatility and permanence of clay. It has been used throughout history as a basic building material, for vessels and for documentation. Now, even more than before, it has such a variety of uses, engine parts, space shuttles, covering tiles, teeth, bones, and dinner plates. My particular fascination lies in its availability and ease of working and its use as a permanent document of the time of manufacture, style, history, events, techniques and peoples are illustrated through clay objects, often the only surviving artefacts.'

Stephanie Outridge-Field is interested in a visual language of selected symbols which she has used consistently in her work over the last eight years. These are representations of human intervention in landscape and human constructions, in particular, cityscapes. Her concerns are for 'patterns of movement, of similarities, of what I find we all have in common to qualify our humannesss. More recently I have been interested in recording evidence of particular events, not, as previously, just the remaining constructed markers but of time and location now. These two facets of being a clayworker using the material, my manipulation of it, and the object's format hold great interest for me. Clay is magical in the sense it has been used by almost every people; it can be slopped, dripped, thrown, bashed, blasted, etched, fired, pierced, gouged, rolled, broken, eroded, coloured, and so on, ad infinitum. In the process of manufacture of a clay object I want to bring out the clayness. To do this I handbuild my work and I do not use any glaze, only colours that are mixed with clay to form a liquid clay slip. I use enamels and can add colour during the firing process. I also use non-permanent colourants of pencil crayons and metallic leaf. I like working with the fired surface, etching and sandblasting to bring another level of surface decoration.

'Most of my work is wall pieces with few freestanding works. I am continually interested in exploring new ways of working, I enjoy working with and talking to others who love clay.' David Seibert wrote in an article *Three Contemporary Clayworkers*, 'The work of Stephanie Outridge-Field is charged with an energy and sense of immediacy, addressing itself to issues and impressions she gathers directly from her environment. She excels as an experimenter and innovator, with the ceramic medium used purely as a vehicle of expression... She is concerned with the outward signs of the controlled human society with its regimentation reflected in our grid-patterned cities, the geometric structures we inhabit and our general conformity of behaviour. Clay, rather than paint and canvas is the most appropriate medium for her observations and commentary. It permits her to work directly and simply on an intimate scale. Her surfaces are rich and varied, creating a timeless quality about the work. This, in combination with her childlike imagery, creates a most appealing impact.'[11]

In the work of John Odgers we can see evidence of our past history, broken down into isolated pieces of masonry, drawing our attention to past luxuries and indulgences. His current series of work is called *Monuments to Human Folly*. He believes that with this 'modern advanced' world, always on the brink of some disaster, we cannot afford to be oblivious to the lessons from the past. 'If one is able to stand aside from a situation, or look in from outside, that situation often becomes clearer. Its meanings, causes and effects, somehow become more tangible, at least in an intellectual if not physical sense. I am affected by the physical remnants from the past, past realities which can serve as metaphors for events in modern society. The physical qualities of crumbling buildings, museum artefacts or rusted hulks are primitive icons which are to me in some ways *pure*, in the sense of being stripped of action, of being isolated in their own sense of time and space, removed from contemporary action. In fact, it is this lack of contemporary human involvement,

11 *Three Contemporary Clayworkers*, by David Seibert, *Pottery in Australia*, Vol. 25/1, 1985

only suggestive of past action, that helps us understand the contemporary condition and the confusion and conflict that we sometimes find in ourselves. What glares at us from the past is that cultures, countries, civilisations rise and fall, and that the qualitiy of this rise or fall is in direct relationship to their harmony or disharmony with the natural order. Cultures that are or were technically advanced and also have or have had an innate respect for humanity and natural order last longer and at a higher level.'

John Odgers studied at the University of Adelaide, The South Australian College of Advanced Education, East Sydney Technical College and the Jam Factory Ceramics Workshop in Adelaide. He was invited to attend the International Ceramic Symposium in Tennessee in 1985. John Odgers was excited to be working for a month outside his usual environment and with a group of ceramists from all over the world. With no preconceived ideas other than a wish to widen his parameters, he was looking for what was representative of himself and what was around him. His work is described in an article on the symposium for *Pottery in Australia*: 'His interest is in naturally old or broken down surfaces, particularly on architecture and surfaces that originally stressed the lasting value of objects. For this reason he likes the trappings of modern living that have quality surfaces such as the lasting classical designs of Italian tableware.' The tables and totem forms that John Odgers made in Tennessee are, he suggests, 'abstracted symbols, not to be seen as attractive surfaces or even as decorative art, rather the opposite with their peeled layers breaking down to suggest what is happening inside a person. However, you cannot overlay meaning on to a work or make more of something than is really there. Working for a long time to discover particular colour and surfaces cannot be an end in itself.'[12]

Reviewing the work of John Odgers shown at the Jam Factory in September, 1982, Jeff Mincham wrote: 'Making use of a strong base colour, ameliorated by a complicated firing process involving salting and fuming, the final effect is one of fluidity, suddenly suspended. The pots have a fresh buoyant quality enhanced by a lively surface. The form and surface come together with that quality that represents the best characteristics of the modern artist potters' achievements, harmony of idea and materials.'

John Odgers sees the relevance of time to his work: 'I am trying to express ideas in my work and if I am successful the work will affect people and they will relate to it. In the end, only time will tell. All art works will become remnants and so the circle continues.'

(left) John Odgers, *Monument to Human Folly*, 20 x 25 cm, 1986

John Odgers, *Monument to Human Folly 31; the Distance between Men. Apartheid/Unification* series (two pieces), 22 x 25 x 12 cm

12 *International Symposium of Ceramics* by Janet Mansfield, *Pottery in Australia*, Vol. 25/2, 1985

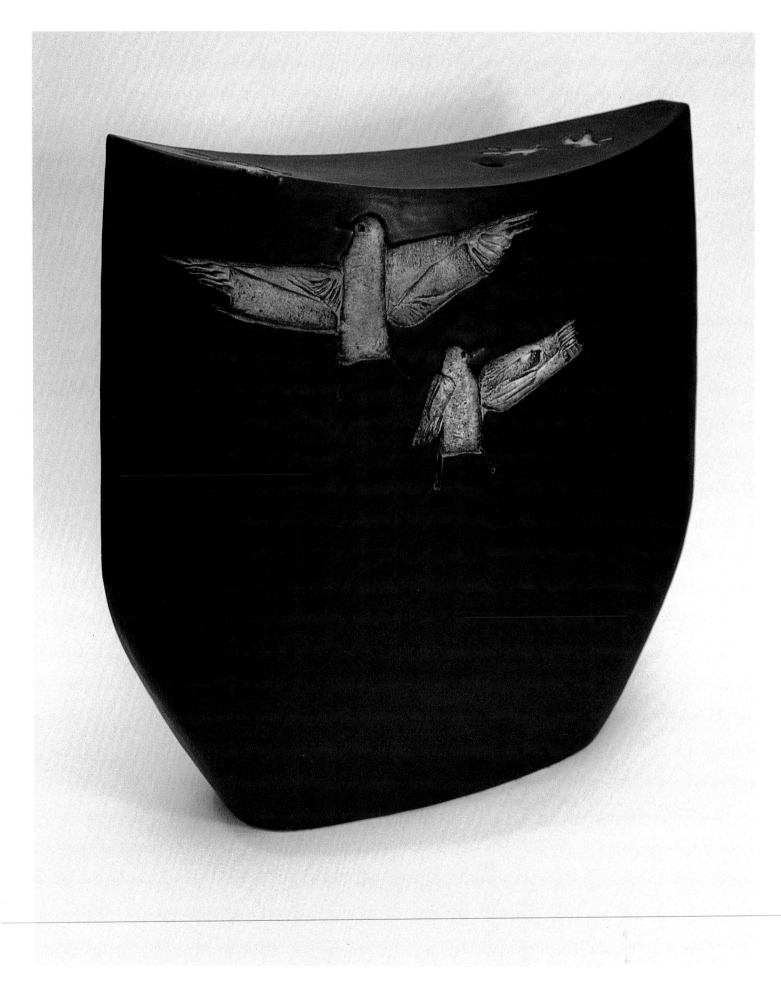

4

THE INFLUENCE
OF CULTURES INHERITED

Throughout the short history of ceramics in Australia, many artists have settled in Australia, bringing with them particular philosophies and the traditions of their homelands. Through their exhibitions and teaching they have had a considerable impact, influencing the thinking of ceramists in Australia.

Hiroe Swen was born in Japan and was trained at the Kyoto Crafts Institute. Since her first exhibition in Australia in 1968, collectors have shown an interest in her work. She believes this interest is due to the timelessness of her work, for it does not attempt to follow any particular modern trend. 'My involvement in pottery' she says, 'is a response to a deepfelt love of clay. People have often told me that without any explanation to them about my work they get a strong message, a warm feeling and a greater sense of peace from viewing my ceramics. If there were to be a message in my work, I would like it to bring a feeling of joy and inner peace to people's lives by presenting, as a positive image, visually appealing ceramic forms which are equally appealing to the touch. This is in contrast to a prevailing trend in art which chooses to depict the negative aspect and thus emphasise a particular point. I prefer to reach people at their emotional rather than intellectual level.

'The prominence of oval and rectangular forms in my handbuilt ceramics clearly indicates that I am also interested in creating the ideal wide canvas for my glaze or relief pattern decoration. That is the reason why I keep the basic form of most of my ceramics clean and simple. Surface decoration on my pots is important to me, but I treat each phase of the creative process, from the finish of the building by coiling to the quality of the glaze firing, with an equal amount of care.'

Preferring always to exhibit her work in her own gallery, The Pastoral Gallery, in Queanbeyan, New South Wales, Hiroe Swen's ceramics can be seen alongside the work of her husband, Cornel Swen, a batik artist, and she has held regular exhibition there over many years. Pauline Green, who reviewed Hiroe Swen's exhibition at the Pastoral Gallery in late 1985, writing for *Craft Australia*, said: 'The 150 pieces shown include vase forms, platters, large oblong vessels, cylinders and bowls. The majority make up a complementary group. Forms are pure and strong. Colours are harmonious, charcoal, sea blues and greens, and white. Rounded edges and thick matt glazes conceal the clay beneath.'[1]

Hiroe Swen says 'I do not try consciously to be a nationalistic potter, whether Australian or Japanese. Influences can come from as far afield as Alaska, Melanesia or Europe. What is important is that my ideas come through in whatever I am doing.'

Hiroe Swen, stoneware form, black glaze with unglazed bird design

1 See *Craft Australia*, Vol. 1986/2

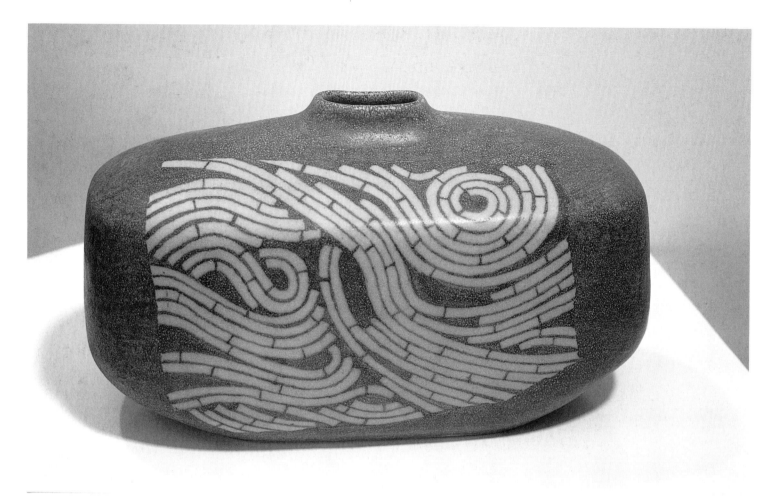

Hiroe Swen, rectangular bottle vase, stoneware

Another Japanese-born ceramist, Mitsuo Shoji has been in Australia for eleven years during which time he has been teaching and regularly exhibiting his ceramics. Mitsuo Shoji studied painting, sculpture and basic design at the Art Institute of the Osaka Museum. Then, in 1971, he graduated with a Bachelor of Fine Arts from Kyoto City University. In 1973 he received a Masters degree from the same university. After some years of travelling and teaching abroad, he decided to settle in Australia where, he says. 'The sense of being a new nation is still strong and I feel there is a lot of potential for a ceramist like myself.'

John Teschendorff, in his review *Mitsuo Shoji and the Japanese Tradition*[2] aligns the work of Mitsuo Shoji with the new Japanese reactionary art born out of discontent with traditional Japanese ceramic values in the post-war period. Teschendorff writes that the institution of a system of living national treasures, designated by law and subsidised by government, ensured the survival of traditional Japanese arts that satisfied orthodox Japanese and Western traditionalists. 'It also made violent reaction a foregone conclusion. Out of the post-war conflict came the inevitable philosophic reaction to traditional ceramic order... which severed links to rigidly formalised aesthetics and rejected notions of function and purpose in the visual arts.'

Although Mitsuo Shoji says 'I am a potter who makes pots, plates and tableware,' he also believes that ceramics should not only be used in that traditional manner but can have other conceptual expressions, even while using much the same processes. Sometimes he uses clay in its raw unfired state, sometimes in conjunction with wood and metallic leaf, to make statements about his perception of life and the environment he has come to enjoy. 'To discover that the native Australian plants

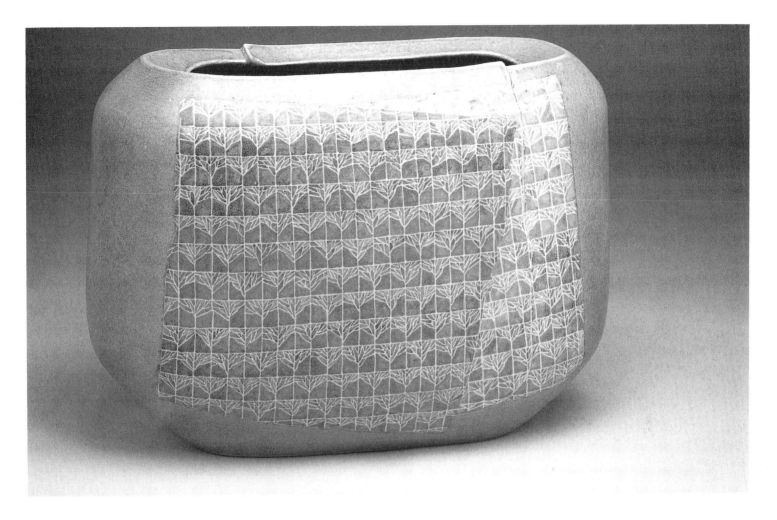

need fire in order to release seeds from their rough seed pods, has a parallel with the Buddhist concept of cremation, when a soul passes from this world to the next' was of significant interest to Mitsuo Shoji.

Hiroe Swen, oblong pot, 26 x 44 x 20 cm

On Shoji's work, John Teschendorff writes: 'The ceramic paintings *Human Thought* and *Universal Thought,* experimental installations at Melbourne State College's Gryphon Gallery in 1982, extend through dependence upon traditional firing processes to simultaneously confront material and imagery. Concept becomes one with content.'[3] Teschendorff writes that the work suggests the theme of transience, appropriately expressed in the clay techniques used; 'Clay slip is dribbled, splashed or sponged on to masked areas of board then sintered into a fragile permanence by controlled application of flame.' By this means, 'Mitsuo Shoji acknowledges the duality of his existence, Western and Oriental, heaven and earth, creation and death.' The semi-permanent nature of the works is suited to the expression of ideas about time and individual reality. John Teschendorff writes 'Watching the clay surfaces shrink, crack and fall away... reinforced a feeling of vulnerability – of the inevitable mortality of man.'

Dr Peter Emmett reviewed the exhibition *Asian Interface,* held at the Craft Council Centre Gallery, Sydney: 'The human condition dominates Mitsuo Shoji's new work: the body trapped, sectioned, burnt, layered, isolated in beauty and decay. The body in tension, but also in repose, inseparable from the layered structure surrounding it, our social and physical condition. Shoji's forms also draw upon a significant image beyond the figurative. The ceramic form is layered and cross sectioned by timbers in a matrix of vertical and horizontal lines. The clay walls of Japanese houses use timber struts and reinforcements to hold the clay. As it

3 See *Pottery in Australia,* Vol. 21/2, 1982

4 See *Craft Australia,* Summer, 1983/4

Mitsuo Shoji, clay painting

weathers and decays the timber scaffolding is exposed, jutting across and through the form. Trial by fire is an important symbol for Mitsuo Shoji. He is both fascinated and annoyed by the kiln-fired process because works are finished beyond his control.'[4] Emmett quotes Shoji: 'My works' says Mitsuo Shoji, 'represent two concepts, myself in relation to the two cultures which I span, and myself in relation to our inevitable passage through life.'

Diogenes Farri was born in Valparaiso, Chile, a third generation ceramist, learning skills early in the family ceramics workshop. In 1966 he received his Masters degree from the Vina Del Mar School of Fine Art. In 1971 he came to Australia where he continues to teach and exhibit his ceramics. He has become known for his specialised work in the ancient technique of burnished surfaces using fine and coloured clay slips. Diogenes Farri writes: 'Art school taught me about art or at least made me aware that many forms of art existed and gave me the experience and the skills of painting, sculpture and printmaking, skills that complement my ceramics. I never felt the need to categorise or consider that one art form is superior to another. My early training as a potter was reinforced and consolidated by artistic awareness acquired at art school. Now I see my work as a contemporary statement about my culture, my time and times past. The extension of the achievment of my father's workshop and all the combined experiences that have emotionally moved me now support and nourish me and result in the work that I do. The necessity to transform an imaginative content into a visual representation deals with the need to recuperate a lost reality, an idea, a feeling or emotion, an external or internal

Diogenes Farri, blue and red form

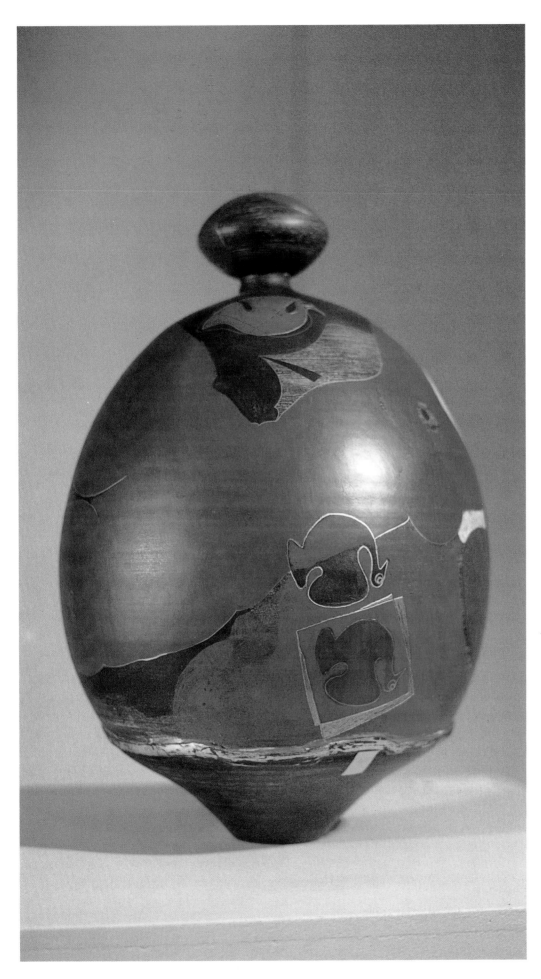

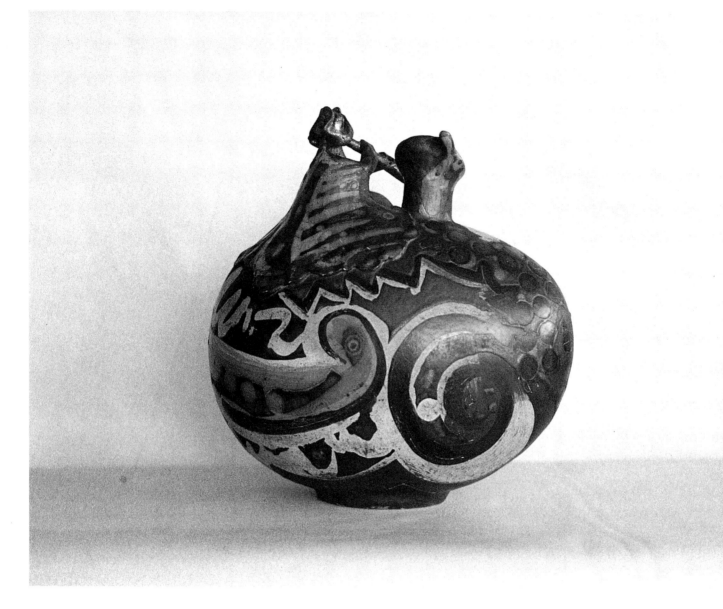

Diogenes Farri, blue and beige vessel form

experience, all need to be dealt with in a creative way.

'In the process of transforming the perceptive world into a symbolic representation we can recognise a link between us and those who have gone before and who contribute in one way or another to the world of consciousness. The same needs that move us moved previous generations right back to the earliest cultures. In this way I feel part of a continuum. The Nazca and Mochica ceramics, the jewellery of Calima and Muisca, the textiles of Paracas and the architecture of Cuzco and Machu-Picchu are the sources of my inspiration. I choose these, not only for their artistic relevance but also their cultural and political implications. From this perspective my mind has built up a vocabulary of images. They express my joy and admiration for the pre-Columbian Art and the belief of the potential and aesthetic value this ancient art can contribute to our time.'

Meredith Hinchcliffe, in reviewing Diogenes Farri's work at the Narek Gallery in 1984 said: 'Farri has created unusual pots by combining old techniques with modern technology. Primitive art and pre-Columbian motifs have inspired the ornamentation, while forms have been derived from ancient Inca pots. The large, simple forms are both pictorial and sculptural. The *Titicaca Boats* series show images of boat people he recalls from his past.'[5]

5 See *Pottery in Australia*, Vol. 23/2, 1984

Neville Assad, three vessels

Lelio Missoni refers to the pre-Columbian influences on the work of Diogenes Farri: 'The work is sometimes original in respect to the content, other times in respect to the form and almost always with regard to the matching of traditional content with traditional forms. Recovering some of the suggestions received from the pre-Columbian art of his native South-American country and having them react with some suggestions of the post-impressionistic European art, Farri knows that the end of this process... can result in an original art object.' In a later review, again by Meredith Hinchcliffe for Craftarts : 'The pots have a serene but commanding presence which is both graphic and sculptural. These vessels which are influenced by pre-Columbian culture, appear to be suspended in mid air. Despite the employment of ancient techniques, the resulting work is vital and fresh.'[6]

Neville Moneer Assad received his Diploma in Ceramic Design from the South Australian School of Art in 1976. Although he was born in Australia he retains a sense of identity from the Middle Eastern origins of his parents. He has returned to Lebanon twice, and worked in the village pottery of Rasel Martin in Lebanon in 1974. Currently working as Ceramic Workshop Supervisor at the Meat Market Craft Centre in Melbourne, he is exhibiting his work throughout Australia.

Clinton Greenwood, Exhibitions Officer of the Meat Market Craft Centre writes of Assad's work: 'His recent pots are characterised by an exploding energy. The agony and frustration of being part of another country and yet being denied access to it because of the civil strife in that land, is clearly evident in some of his work. The manipulation of the clay is direct and spontaneous, the surface embellishment displays restraint in the use of glaze and oxide. Neville Assad's pieces reflect an understanding and concern for the Australian landscape while the duality of concept orientated towards both this country and the Middle East strengthens the effectiveness of his statement. Therefore his work reflects the multi-cultural nature of the Australian society, sitting comfortably within a developing Australian tradition. A contemporary political concern is apparent beyond the well resolved and aesthetic appearance of Neville Assad's work. This quality is shared with the great art of the past.'

6 Article *The Work of an Andean Ceramist*, Vol. 24/4, *Pottery in Australia*, 1985

7 Meredith Hinchcliffe, *Echoes from the Andes*, article in *Craftarts* 2, 1985

5

THE INFLUENCE
OF CULTURES ADMIRED

Not finding a strong tradition of their own, Australian ceramists have looked for inspiration to cultural traditions from around the world. Journeys, study trips and prolonged working experiences overseas made by our ceramists have given rise to the enthusiastic adoption of many different cultural styles. Travelling international ceramists, involved in workshop tours or artist-in-residence at tertiary colleges, imported touring exhibitions and readily available overseas books and magazines have all contributed to a broader base of influence. However it is the adaptation of these exotic styles to suit the Australian circumstance, the absorption and subsequent diffusion of the underlying and borrowed philosophies that has resulted in some unique and individual work. Japanese ceramics, with its millennia of tradition and the role of the potter in that society, has been a most significant lure for aspiring potters from many countries. The writings of Soetsu Yanagi, through his book, *The Unknown Craftsman*[1] aquainted potters with the Japanese ideas of beauty and excited many to seek this 'way of grace' for themselves. Yanagi talks of the 'power of tradition' not dictated to by fashion, saying 'passing time cannot affect an object that is truly beautiful'. A love of nature, this timelessness of art and a concern for the common good through individual effort are aspects of a philosophy that artists and craftspeople are attracted to as a personal code for work and life. This chapter concentrates on some Australian potters who have been inspired by both the aesthetic philosophy and the ceramic arts of Japan.

Jane Barrow, Andrew Halford and David Walker have all spent many years in Japan, working and studying and have brought to their work, now being made in Australia, styles typical of Japanese traditions.

Jane Barrow spent seven years in Japan, studying at both Shigaraki and Bizen. During her years in Japan she was sponsored to build a Bizen-style kiln and also to exhibit her work. Her formal studies in Australia included a Diploma in Advanced Ceramics from the Perth Technical College, 1975, and a Bachelor of Arts degree, majoring in Craft and Design, from the Western Australian Institute of Technology in 1976. She returned to Australia in 1984 and now works as a full time potter having set up her workshop and kilns in Ourimbah, New South Wales. Jane Barrow's training in Australia and Japan has influenced her to work with traditional shapes, using traditional firing methods, unique to the specific areas where she worked, that reveal the surface qualities and textures of the clay. 'This aspect of my

Jane Barrow, slab platter, slip decorated under clear glaze, 36 cm/d, 1986

1 *The Unknown Craftsman* by Soetsu Yanagi, published by Kodansha International, 1972

Andrew Halford, stoneware pot, inlay decoration saggar fired, 30 cm/h

work is of primary importance to me' she says, 'and although the traditions (in recent history anyway) of these areas revolves to a large extent around tea ceremony utensils, which govern dimension and shape, it is perhaps not relevant in this society to reproduce them, However, there are qualities in this tradition which can be translated for use and appreciation in our own society in Australia. The primitive roughness of the clay with the intense marking from the fire combined with an elegant simplicity of shape gives the work strength and surface character. I use a slip decoration to enhance the fire patterning.

'My aim is not to produce fashionable work that has a limited time span of appreciation, but is to produce quality work, balanced in its form and decoration, which can stand by its own strength whatever the current trend might be. Although I am influenced by the traditions from Japan, I hope my work will develop its own cultural strengths as a result.'

Andrew Halford first trained with the Japanese potter, Shiga Shigeo at his Sydney workshop. After travelling and then working with Les Blakebrough at the Sturt Workshops, then working for two years in a commercial pottery, he went to further his studies in Japan. He spent five years in Japan, working with Shimaoka Tatsuzo in Mashiko, who specialises in slip inlay work, and Shimada Haruo from the Shimane Prefecture who is noted for his large storage jars made by the coil-throw method. Returning to Australia in 1979, Andrew Halford took over Shiga Shigeo's workshop and started his own production of domestic and individual wares. During this time Andrew Halford has trained a number of apprentices. He says about his work: 'My work is based on a tradition of technique, learned both in Australia and Japan over a ten year period. I strive for perfection of craftsmanship to the point where I need not be conscious of my hands but let the clay flow naturally. At this point a potter can begin to develop the eye and the spirit and achieve harmony and balance. When this happens, these qualities should be easily and clearly interpreted and appreciated by others. The work then speaks for itself.

'At the moment I am using the slip techniques of inlaying patterns, using surface textures from shells, rope, stamps and various nuts and seeds that I find in the surrounding bush. I draw my inspiration from nature, but also from other art and

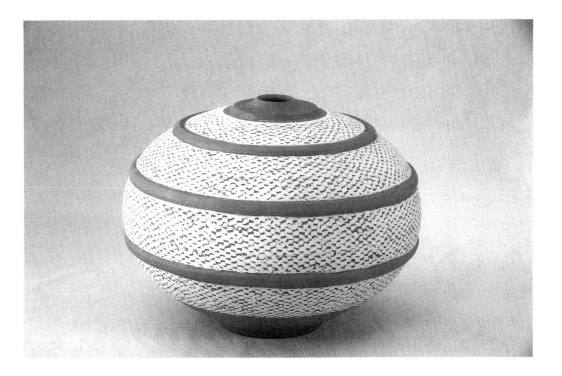

craft work made by people who have lived naturally in harmony with their environ-
ment. I am seeking this balance in my life which will, in turn, show in my work.'

After four years working in traditional wood fired potteries in Shigaraki, Japan,
David Walker returned to Australia to explore a similar aesthetic, making wood
fired and contemporary individual work. He says: 'Firing with wood today could be
considered technologically backward. However, considering all its advances,
science still has not discovered a substitute for the beauty and variety that firing
with wood imparts. Wood firing using a tunnel kiln designed to create a draught
which carries flame and ash through a stack of raw pots, pots possibly with
wrappings of vegetation, is always unpredictable in its process and results. A potter
can only control the fire and ash and clay to a certain extent. Nature and the
elements control the final results.'

David Walker wood fires his individual pottery and utilitarian wares in a large
single chambered tunnel kiln which is built into the ground on the side of a
mountain. It is fired for four to five days to reach temperature and achieve the
desired results of clay quality and ash deposit. During the firing the raw pots are in
constant contact with flame and ash. Results depend on many things: the choice of
materials, the method of packing the kiln as related to the number of pots to the
volume of the kiln, the juxtaposition of pot to pot and pot to fire, the looseness or
tightness of the packing of the stack of pots, the speed of temperature rise, the
balance of the fire and distribution of embers, the length of the firing, the control
of the temperature, quantity and type of timber used for fuel, the cycle and method
of stoking, the balance of the oxidising and reducing atmosphere in the kiln and the
climatic conditions of wind, rain or snow.

David Walker chose to build his workshop and kiln on the eastern slopes of
Mount Rankin, 20 kilometres north west of Bathurst in central New South Wales.
The site has panoramic views, a natural bush setting, privacy, abundant fuel
supplies and an atmosphere conducive to his style of work.

He says: 'Each pot is truly a one-off piece, individual and for contemporary use.
My work reflects my life and working environment.'

Susan Brophy, reviewing the work of David Walker at his exhibition at the

(above) David Walker, bowl, *Anagama* fired, 32 cm/d

David Walker, bottle, *Anagama* fired

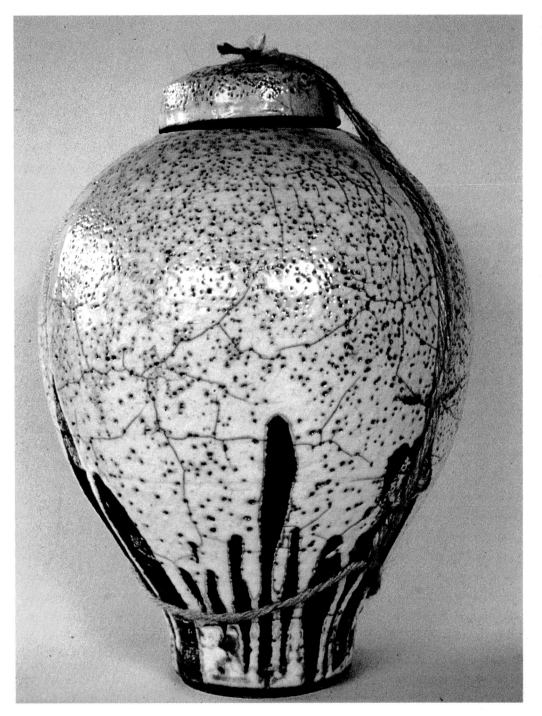

Bruce Anderson, lidded jar, sodium glaze, 42 cm/h

Sydney Opera House, January, 1986, had this to say, referring to the strong, symmetrical bowls: 'Varied in form, the bowls in general tended to have pale toned and rough clay surfaces, showing the lighter effects of ash and the shadows of the straw. These elements combined to give a visual sense of expansion and lift from foot to rim. In these well considered forms, strength remained strength and not weight, while the firmness of touch from hand and tool retained a gentle quality.'[2]

A love of the forms, surfaces and character of Japanese pottery has led a number of Australian potters to explore specific qualities and techniques for their own sake. Bruce Anderson, Bill Samuels and Ben Richardson are among these potters.

'To make the kind of statement that Ben Richardson is trying to make calls for perseverance and singlemindedness of purpose. He has a commitment to the use of the raw materials from within his own area in Tasmania. If one can appreciate the

2 See *Pottery in Australia*, Vol. 25/2, 1986

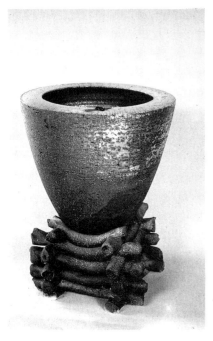

Bruce Anderson, ceremonial vessel, 31 cm/h

(*right*) Bill Samuels, teabowl, *Shino* glaze, multiple firings, 1986. Collection National Gallery of Victoria

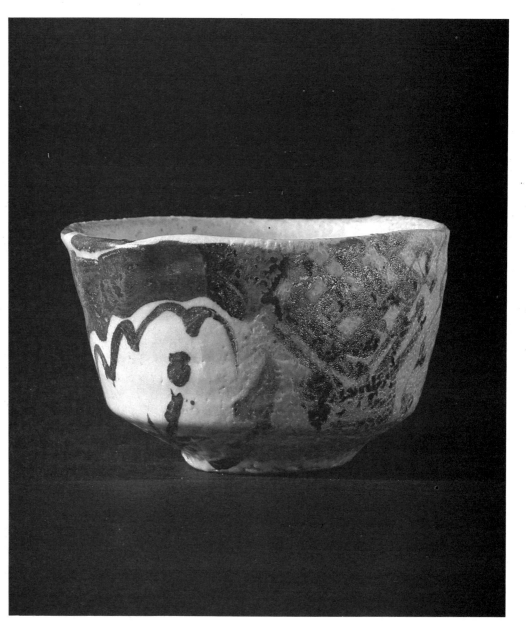

physical and mental effort to keep a wood kiln burning for two or three days, non-stop continuous stoking, one can have some idea of the energy that is required to produce these pots.' Les Blakebrough was reviewing Ben Richardson's 1986 exhibition at Handmark Gallery, Hobart. Blakebrough went on to say, 'Ben Richardson is a young potter with energy and talent, purpose and integrity, for collectors I suggest you watch the work, it is good now and it is going to get better.'

Ben Richardson studied ceramics at the School of Art, Hobart, after having received a Bachelor of Commerce from the University of Tasmania. He established Ridgeline Pottery in 1981 producing wood fired functional pottery. He writes about his work: 'I feel inspired by and connected to the craft tradition of handmade pottery, that very long history of people all over the world making pots for daily and ritual use. For me, inspiration and aspiration go together and I would hope to make pots that serve the needs of people in our society today, pots that combine utility and aesthetics. By using local raw materials, as they have always been used in folk craft traditions, I seek a naturalness in my pots. My large kiln takes me three to six months to fill and two or three days to fire using local timber as fuel. Using wood as fuel provides not only the historial connections but allows for the firing to change

Bill Samuels, lidded vessel, *Shino* glaze, 15 x 16 x 16 cm

the surface of the work, with fire marks, ash deposits and atmosphere changes within the kiln.'

Bruce Anderson's work in clay has been based around the processes associated with *Raku* and blackware. Simple vessels, particularly basket forms, based in part on the formalities of the Oriental tradition have been a strong influence on his work. He says, 'I believe that a simple or limited approach can open processes and technology allowing for a type of creativity that is less restricted, free of the constraint of those processes.'

Bruce Anderson's work at the Narek Gallery was reviewed by Nola Anderson for *The Canberra Times* in March, 1985. She wrote: 'Anderson's work certainly does dip into an Oriental vocabulary, but it is based on a concept of sculptural form that is very much based on this decade's interest in personal expression. On first look, Anderson's work appears to focus on construction, the interplay of forms and the imagery they create. Behind this though, there is an obvious enjoyment in the clay, its softness, roughness, weight and plasticity. These qualities stay in the final expression despite the transformation into rigid ceramic in the firing process.'[3]

Bruce Anderson gained his Diploma of Fine Arts, Sculpture, from the Prahran

3 Nola Anderson, *The Canberra Times*, March, 1985

(above) Ben Richardson, bowl, wood fired, 27 cm/d

(right) Ben Richardson, box celadon glaze 11 cm/d

(far right) Ben Richardson, teapot, iron glaze, 23 cm/h

College of Advanced Education in 1971, following this with a Diploma of Education from the State College of Victoria in 1975. He became a teacher of ceramics at Townsville, then Toowoomba and now is Senior Lecturer at the South Australian College of Design, responsible for both clay and glass studies. Recently he has been undertaking some postgraduate studies at the Gippsland Institute of Advanced Education. He writes: 'My education started in Melbourne as a child of the outer suburban fifties. With the encouragement of some enthusiastic art teachers, I decided to make art my career. Art college was an exciting environment, it was a period of great social change with everyone questioning the values that had pervaded our middle of the road comfortable society. In the art school, exception became the norm, where anything that happened was not dismissed and from that period of change and exchange, many of us were given new insights. Art was a challenge that could affect people in a direct way.

'Sculpture is, I believe, the art form that is most void of any constrictives,

Bill Samuels, covered box, wood fired, 1985.

extending into sound, light and theatre using elements to affect the senses and emotions and I wished to maintain my participation in the visual arts. I was drafted into the National Service for approximately 12 months and from there worked in a commercial pottery which cast or jiggered and jolleyed mugs and bowls. Although I did not appreciate it at the time, for the work was laborious and repetitive, it was quite a rich experience and the knowledge gained was invaluable.'

Bill Samuels studied ceramics at East Sydney Technical College in 1968, after originally training as a painter and travelling the world visiting potters. He says his year of contact at E.S.T.C. with such potters as Peter Rushforth, Mollie Douglas, Shiga Shigeo, Bernard Sahm, Peter Travis and Derek Smith gave him the necessary impetus and direction to survive the early years as a potter when everything seemed to go wrong and cost so much. Although his parents had endeavoured to push him into a life in commerce, Bill Samuels decided 'that a wholly materialistic view of life lacked balance. Artists are essential members of society and responsible for encouraging, nurturing and providing beauty in life.' Samuels put his artistic endeavours at first into making *Raku* pottery, enjoying the softness of the clay quality of *Raku*. Discovering the *Shino* wares of 16th century Japan, he found the same softness and variety in the work. He says 'it took me a long time to work through the belief that technology could provide me with the qualities that I wanted in my pots. There are no rules for making good pots, only intuition and an infinite number of variables. The right clay, kiln, firing, good weather and feeling

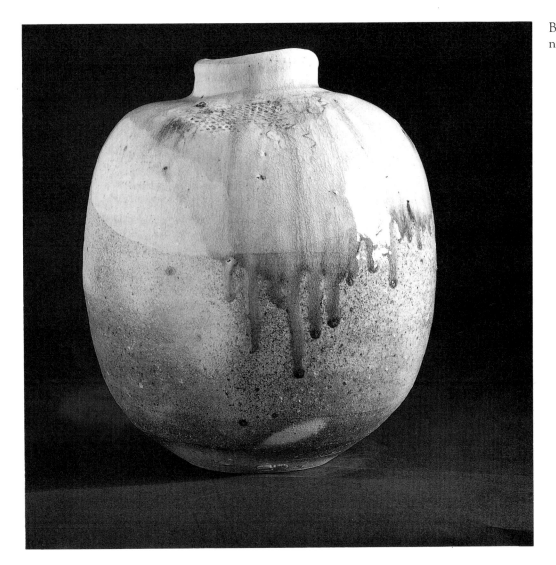

Bill Samuels, bottle, *Shino* glaze, natural ash deposit, 1985

happy are essential minimum requirements, without guarantees, for making good pots. I fire with wood in my 4 metre long *Anagama* kiln; it is sympathetic but not necessarily efficient. Efficiency is not a consideration when I try to make beautiful pots.'

Using a rough clay, often with stones still in it, covering the pot with a thick coating of glaze while the pot is still raw or unfired, Bill Samuels is seeking for particular effects that team together and with him. He is beginning to redecorate and reglaze work if he is not satisfied with it, often four or five times if necessary. 'I decorate a lot of my work, I think it is the painter coming to the fore. Mostly I use iron oxide but recently I have developed a range of enamels to paint some of the pieces along with gold leaf. Colour heightens the impact of the work and relating colour to the surface qualities of the glaze and to the form is a new and exciting challenge.'

Reviewing his exhibition at the Sydney Opera House, January, 1986, Susan Brophy wrote: 'Bill Samuel's pots, particularly the bowls, both open and cup like in form, echoing influences from Japanese teabowls, were soft yet energetic. The *Shino*-like glaze revealed its potential for change as the different effects of the kiln's atmosphere moved from internal to external surfaces, blushing from orange to pink, surfaces with qualities from a pebbly dryness to the lusciousness of icing. The glaze is able to react without subduing the gesture-like quality of the brushwork decoration.'[4]

4 Susan Brophy, reviewing an exhibition at the Sydney Opera House, January, 1985, for *Pottery in Australia,* Vol. 25/2, 1986

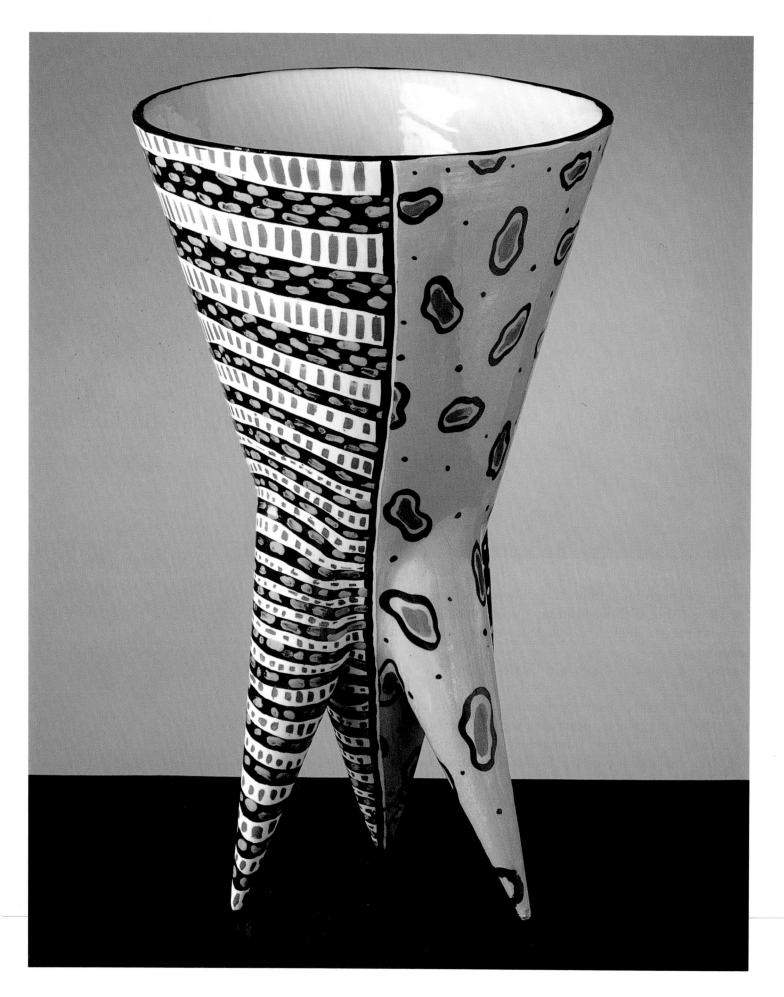

6

AESTHETIC CONCERNS

The consideration of aesthetics as a basis for personal expression in object making is, currently, attracting a number of artists working in clay. The immediate nature of clay and other traditional ceramic materials, plus the energy and vitality of creativity for its own sake add up to perhaps one of the most innovative and exciting areas of ceramics today. Colour, line, figurative form, abstraction, spatial tension, exaggeration, historical allusions and innovation are all aspects of concern and delight to these artists.

While some potters are being lured away from the functional pot into the more expressive realm of decorative arts, many are using the vessel form to state their concept of art and issues. Jenny Orchard comments: 'I am still drawn to the concept of vessels and containers, but as departure points for forms rather than as functioning objects – for example, the cultural idea of what a teapot is, rather than its practical use. All through the ages pottery has been used to embody information, not just about the individual that created it, but also of the culture that produced both the individual and the pot. I hope that by constant reference to contemporary images and schools of thought that my work expresses a little of the culture in which I live and have lived.'

Jenny Orchard's work has been called 'urbane post-modernism... which transcends the stifling decorum and precocity usually associated with the crafts' by reviewer Terence Maloon, writing for *The Sydney Morning Herald*[1]. Jenny Orchard writes about her work: 'It is about the relationship between the two dimensional arts of painting and drawing and the three dimensional arts of ceramics and sculpture. A pot has a *reality* of its own, unlike a painting or drawing which is always about something rather than being something. When one first looks at a pot, mostly one sees an outline. When I first started designing ceramics, the shapes were never symmetrical, they felt good that way. So I set out to make asymmetrical pots, that, while they are about drawing and line and incorporate drawing and line, are utterly three dimensional.'

In writing about Orchard's 1986 exhibition at Macquarie Galleries, Sydney, Peter Timms said: '...the interplay between the three dimensional and the two dimensional becomes increasingly more subtle and sophisticated. Painted decoration is used to accentuate the form, here to cut across it and alter it.' Jenny Orchard responds: 'I try to have the form and decoration completely interdependent on each other. Slip casting allows me to try out different imagery on a

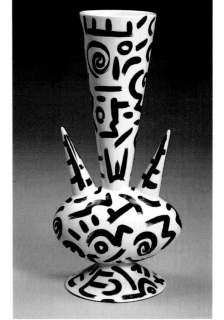

Jenny Orchard, vase form

Jenny Orchard, bowl form

1 From the review by Terence Maloon of the collaborative work of Jenny Orchard and Robin Gordon at the Macquarie Galleries, *The Sydney Morning Herald*, December 1985

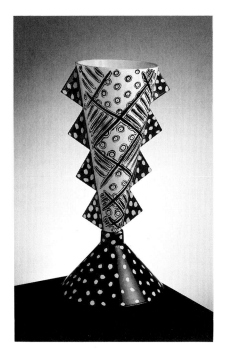

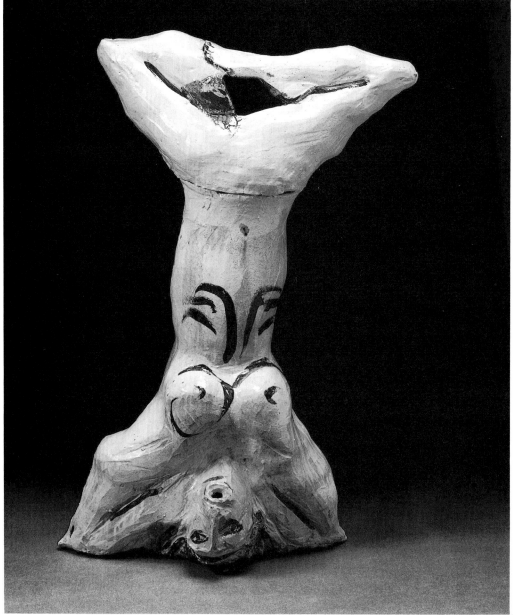

(*above*) Jenny Orchard, vase form

(*right*) Alice Nixon, *Yoga figure*, 101 x 60 x 30 cm

particular shape – I can come up with multiple decorative solutions to integrate with the form. Also, the shapes are designed so that they can be used to produce a number of different pots by cutting and assembling the basic cast shapes. In this way the number of individual forms is limitless.

'The method of slip casting is labour intensive when applied to a small studio output. First a shape must be designed and then a marquette made from that design. Then a mould must be made and the piece cast. Casting large pieces is difficult, messy and physically demanding, even if at the same time exciting. A few minutes too long or too short when casting can mean disaster. The pure white commercial clay that I use gives an excellent finish but it is difficult to handle and I would be optimistic to say that more than 50 per cent of the work is completed without mishap due to cracking or glazing problems. After the marquettes and moulds are completed each piece takes at least a fortnight to make. In the future I plan to work on a larger scale, in particular with murals, using concrete and ceramics, to form large sculptural pieces for architectural use.'

In an article on Jenny Orchard, written by Jan Mackey for *Craft Australia,*

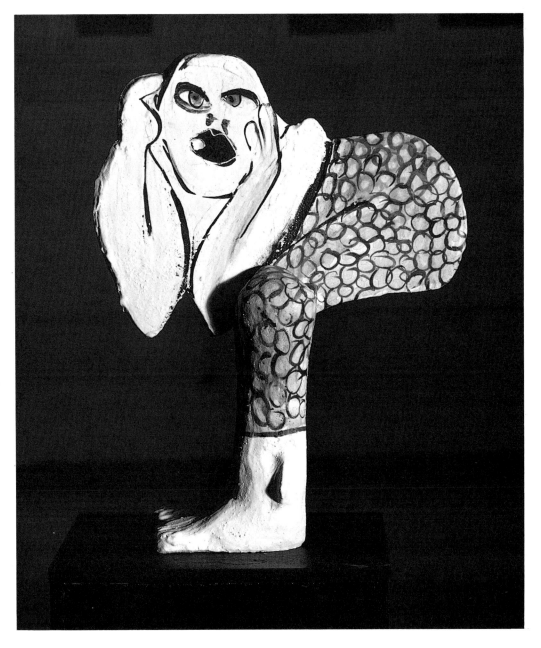

Alice Nixon, figure

Orchard is reported to have said: 'Utility is not my primary consideration, aesthetics is.'[2] Jan Mackey concludes her article: 'Orchard ceramics have the charm of laughter and confident colour, the elegance of strong and vigorous line, and a headstrong sense of individuality. Sometimes the flavours of the luxury movements of Art Deco or Art Nouveau are apparent, sometimes there are punning plays on the painters and potters of fame and fortune. But the overwhelming sense is that of the potter herself, of the childlike simplicities that are so hard to achieve.'

In another review, Peter Haynes wrote: 'Orchard's work is redolent of the lino and laminex of the 'fifties. She uses quirky angular forms as the base for her explorations in the application of pattern and colour. Her surfaces are lively, sometimes even frenetic, but they remain very much an integral part of the pot on which they sit...'[3]

Alice Nixon graduated with a Diploma of Art from the Phillip Institute of Technology in 1984 and then completed a Post Graduate Diploma in 1985. She was invited to participate in a symposium for young ceramists in Canberra in 1986. She talks about her feelings to working in clay. 'There is no tool or brush to separate

2 Jan Mackey for *Craft Australia*, Summer, 1983/4

3 Peter Haynes review of the exhibition *Clothes and Clay* at the Orange Regional Gallery for *Pottery in Australia*, Vol. 24/3, 1985

Alice Nixon, vase form

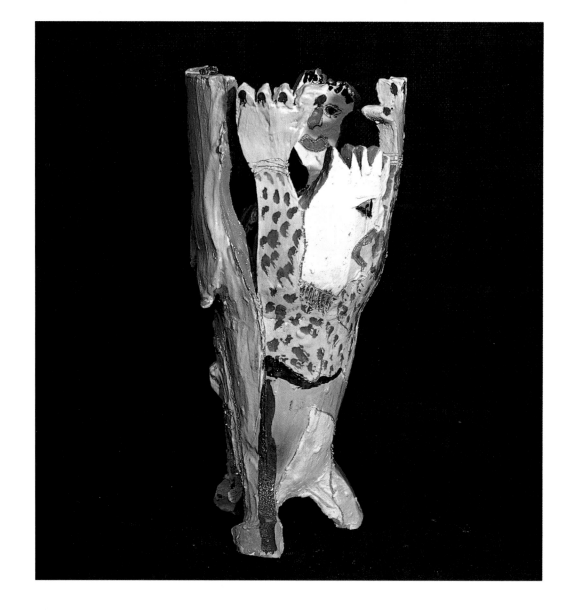

the medium from the maker', she says, 'and it is this spontaneous nature of clay that I try to use and retain. A fleeting moment can be translated into form and be permanently preserved. I prefer handbuilt forms as I feel they are more akin to nature and are the most appropriate for the depiction of figurative forms. Handbuilding also prevents any lapse into mass production, so avoiding overworked ideas or forms that express laboriousness.'

If the processes and materials influence the ceramics of Alice Nixon, it is the aesthetic considerations that finally shape the work. 'The medium of ceramics attracted me, not only for its wonderful texture but also because of its challenging nature.' Alice Nixon feels aligned with the philosophy of ceramist Roger Fry of the Omega Workshops when he wrote: 'Pottery is, of all the arts, most intimately connected with life, and therefore the one in which some sort of connection between the artist's mood and the life of his contemporaries can be most readily allowed.

'The emphasis in my work is on aesthetics rather than function or technique and I repeat myself only if I feel there is something new to be gained. Most of my inspiration comes initially from the clay and then from the challenge of the work to be undertaken.'

A recurring theme in Alice Nixon's work is 'motion suspended in time' which

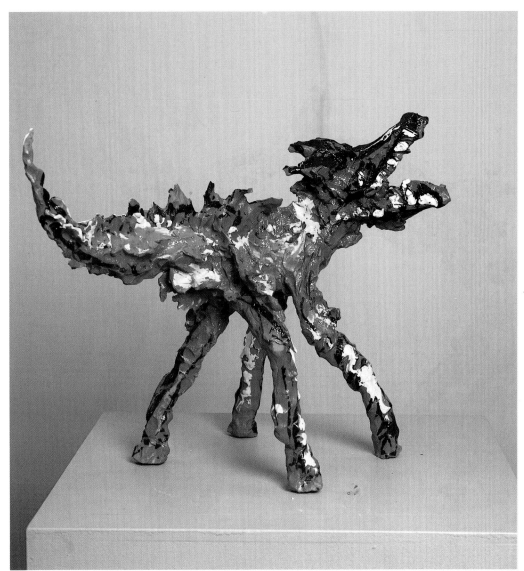

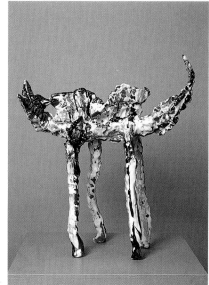

Patrick Lacey, *Terracrue*

(left) Patrick Lacey, *Terracrue*

requires spontaneity to be expressed by working directly, even roughly, and seemingly haphazardly. 'It is a challenge to me to make a sculpture look as though it was completed in a brief flash of excitement even though it is technically impossible and actually took many weeks to build. The initial inspiration must be maintained through the building, drying and firing before being brought to life again by decorating and glazing. This is dictated by the peculiar nature of clay.

'In eschewing realistic representation, my intention is to disregard strict perspective and sophisticated slickness in favour of the simplification to basic elements seen in enduring primitive styles. Some of my work is left undecorated as I felt that to do so would be superfluous and would deflect the viewer's attention from the strong lines of the form. Texture and tactile qualities are an integral part of sculpture and I would hope that the invitation to touch is obvious. I wish the viewer to sense the pleasure that I gained from using clay.'

Renaissance art, music and architecture, particularly the frescoes with their depiction of the aggression and stance of animals provide the inspiration for the latest work of Patrick Lacey. 'I combine the architectural qualities in the formation of tall pillars, with prowling excited animals. The pillars give the work a theatrical image whilst the animals are created in a frenzied manic approach resulting in sheer ecstasy.' Lyn Baines described Lacey's working methods as he prepared for an

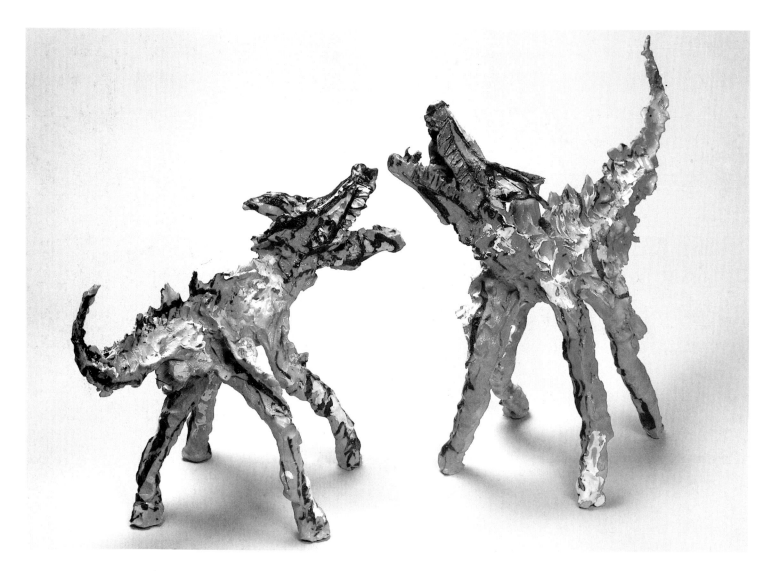

Patrick Lacey, *Terracrue Pair*, 50 x 57 x 30, 59 x 65 x 27 cm

exhibition *Gothic Reminiscence* shown at the Blackwood Gallery in 1986: 'The energy and enthusiasm by which Patrick Lacey works leaves no time for ponderance, as his hands move confidently with the clay. He always starts with prolific drawings using music as a catalyst for design, particular church music from the 13th to 18th century being favoured.'[4]

'Clay has a spontaneity that no other medium has for me,' says Lacey. 'I am able to construct large ceramic pieces by coiling, squeezing, pinching and rolling out masses of clay. My work is basically handbuilt from locally dug terracotta. Large pieces of work are constructed and placed one on top of another to achieve an imposing structure. The pieces must be made quickly, allowed to dry a little, painted with terracotta slips and white porcelain slips, then using the form as a canvas, painted with oxides, underglazes and body stains mixed with the porcelain slip to complete the design. These colourants give the pieces expression and movement. The final application of clear glaze, either matt or satin finish, bonds the work together and gives depth to the colour.'

From the commencement of a piece to its final firing in the kiln Patrick Lacey is totally and creatively involved in the process. He finds it a complete and absolute challenge to open the kiln door and be confronted by 'an illustrious, shining, majestic animal'.

Involved in clay work for ten years, Patrick Lacey completed a Bachelor of Fine Art from the Phillip Institute of Technology in 1985. He is currently pursuing post

4 See *Pottery in Australia*, Vol. 26/1, 1987

Susan Ostling, *Jug in Shadow*, 1986
40 cm/h

(left) Susan Ostling, A *Vase with Stripes*, 1986, 45 cm/h

graduate studies at the same institution. His work demonstrates a spontaneous approach combined with a technical complexity. It is large in scale, uninhibited in style and mood and while drawing on images from the past has a relevance to Australian animal imagery and to his own personal expressiveness.

With qualifications in teaching, ceramics and fine arts from national and international institutions, Susan Ostling has received acclaim both as a teacher and for her ceramics. She writes: 'I have found myself drifting into making large pieces of work. This drift has been partially circumstantial, teaching commitments have changed the way I work. Time available for clay work is in precious pockets only allowing focusing on one or two objects at a time. But this new direction has also been desired. As confidence has grown in handling the processes of painted surfaces of clay, projects have become more challenging with work growing in scale and the surfaces more decorative.

'The objects I like to make continue to be drawn from traditional ceramic vessels: jugs, bowls, vases, serving dishes, drinking vessels and so on. However I attempt to rework these traditional objects in a contemporary mode. The objects have distinctly recognised uses but with current patterns of urban living, they mostly do not have specific use. Their *uses* signify a past domestic realm yet their forms and surface treatments place them in the present.

'At the moment I am coiling the larger pieces. This is quite a departure for me as up to now I have enjoyed working with slabs of clay which enabled me to plan

(top) Susan Ostling, *A Spotted Vase*, 1986, 45 cm/h

Martin Halstead, *Instrumental*, 52 x 30 x 22 cm

everything before I started. I would construct the objects from cardboard initially, allowing for play, invention, problem posing and resolving. However, more recently I have found that I have not had the time for that initial planning. Coiling presented itself as a more efficient way to work. I coil and work the clay in a slab like manner... This allows for ideas to be worked out as I go, and even more importantly, it allows me to have several pieces going at one time, setting up dramas and dialogues between the pieces and myself. I like to think of the pieces being companion pieces or friends. With the coiling process, I have found the playing takes place as the work proceeds.

'Decorating objects is, I think, a pleasure/pain experience. I enjoy pattern making and become quite consumed by it. I enjoy analysing pattern, trying to catch hold of the elements, tracking down the elusive and finding meaning and purpose in the markings. I look for the random, the unexpected, the skewed in a framework of ordering. Coloured slips, using commercial stains, are mixed tonally and painted in layers relying on the traditional ceramic techniques of sgraffito and resist to obtain an interactive surface. Ideas and directions come from a range of sources. Folk pottery has always been of interest, particularly French provincial wares and English country pottery, where strong forms meet the demands of kitchens and gardens, and can display unexpected idiosyncratic local additions and adaptations. I often turn to the early tin glazed wares of Persia, Spain and Italy where bold and brightly coloured forms have an earthy practicality yet carry moods and meanings. The decoration on these wares never seems incidental. Contexts, causes and effects, actions, reactions, explanations and analyses fascinate me.'

Martin Halstead acknowleges that aesthetic concerns are an important aspect of his work approach. Making pieces in a series, each one a separate identity within the collective, he says 'each one is a page in my personal diary of asking questions and raising more'. This continual questioning is a search for all the things that have meaning for him. He says: 'The symbolism that I use is derived from my environment, personal experience and history and becomes an autobiography in sgraffito and carving. Each form has been developed over years of working on the theme of the musical instrument. These forms have become the vehicle for surface and tension, symbolising triumph, defeat, sadness and joy.'

Since gaining his Diploma of Visual Art from the Canberra School of Art in 1982, Martin Halstead has worked as Assistant to the Curator at the Canberra School of Art and has been a teacher in the School of Art and Design at the Orange College of Technical and Further Education. In 1986 he was awarded the prize for the best work of ceramists under 26 years of age from the Concorso Internationale della Ceramica D'Arte in Faenza, Italy. He talks about his working methods: 'Working needs honesty and time and I cannot dive into an area that I neither understand nor have an empathy for. With abstract work I need to take time to develop the shapes and motifs so that they retain meaning and strength within the context of the work. Drawing and thinking, merging new and old ideas, collecting information are elements that come together as my articulation grows. Each piece presented at an exhibition needs to be understood from a distance as well as close up. The keys of the instruments break space leading the eye into and away from the work giving it character and the tension which I find a crucial element. Working can be lonely, frustrating and yet rewarding with emotions ranging high and low but I am always learning and building on what I have learnt.'

Reviewing Martin Halstead's work, Peter Haynes wrote: 'Halstead has been experimenting with forms based on Oriental musical instruments for some time... Halstead's decoration forces the viewer to move around the work, at once

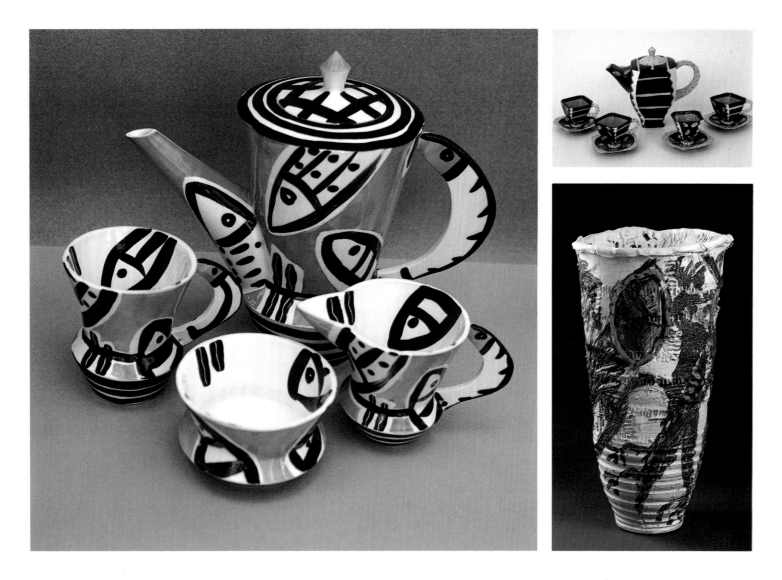

appreciating the subtleties of colour and line which constitute the formal components of the decoration and accepting the three dimensional nature of the object of which it is a part. The perceptual tension is a metaphysical equivalent for the dialogue between surface and form which in turn creates the aesthetic tension which provokes a reasoned visual response. The artist is able to key together the various physical and formal elements with the less tangible conceptual and perceptual elements to create efficient aesthetic entities.'

David Potter graduated with a Diploma of Education from the Hawthorn Institute of Education after completing his studies for a Graduate Diploma in Fine Art from the Royal Melbourne Institute of Technology. Geoffrey Edwards wrote in 1980: 'David Potter's tall tapering *Triton* belongs to traditional discipline. Unlike the widespread involvement with ceramic forms which are primarily sculptural and non-functional, here the potter has restricted his formal investigations to the basic convention of wares thrown on the wheel. With its matt, sandy coloured surface it is detailed throughout its full height with a series of rhythmic furrows – a reference to the craftsman's apparent and careful observation of marine forms as well, perhaps, as a gentle affirmation of the process by which the shapeless clay mass is coaxed into a hollow three-dimensional form.'[6]

Painter and friend Peter Westward writes: 'It is particularly interesting to look at David Potter's work by isolating the image, surface and the form. But I hesitate to deal with his work in this way as it denies the physical conflict, the battle that is

David Potter, large pot, 89 x 50 x 50 cm

(top) Patsy Hely, teaset, Mori Gallery, 1983

(left) Patsy Hely, coffee set, Crafts 86 Exhibition, Meat Market Crafts Centre, 1986

6 *Australian Ceramics in the Collection of the National Gallery of Victoria* by Geoffrey Edwards, *Pottery in Australia*, Vol. 19/2, 1980

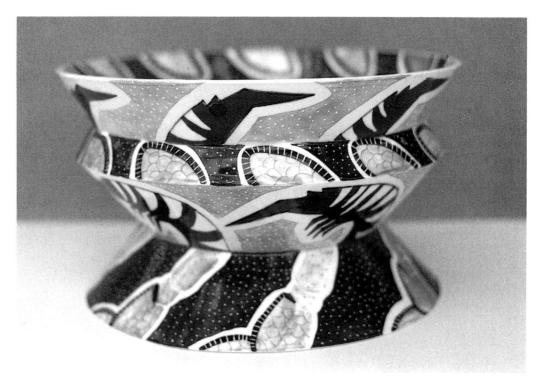

David Potter, stoneware form, 1986

(*right*) Patsy Hely, bowl, slip cast, underglaze colours and coloured slips, 1100°C., 1986

involved in forcing the image, and to isolate these aspects fails to hit on what this work is about and deals only with decoration. Ambiguously, his work could be seen as alluding to the past, through the use of classical form and the deliberate surface decay, but he is specifically dealing with these references as present, as sources now.

'The work is made with such a sense of urgency through such a forceful process, that it appears at times to have a sense of clumsiness in aspects, and a great deal of rawness. It despises wimpy sensitivity and porcelain-like delicacy. But it has many sophisticated subtleties in the way it looks and the way it is read. Wherever one's eye and body happen to wander around his work, everything contributes to the total effect. Scripts and scribbles suggest the ancient city life of the Byzantines and the Egyptians. The form alludes to utility but in the present has no function. To take from the past and use again in the present is symptomatic of post-modernist dogmas, or should I say fashions, however to realise that the past is part of a total decayed present and to accept this is far more ambitious.'

Patsy Hely first started working with white earthenware clay and underglaze colours and slips during her second year of the Ceramics Certificate Course at East Sydney Technical College in 1977. She says: 'I always had a clear idea of the sort of pots I wanted to make and I still do. My concerns are mainly to do with the relationships that exist between form and decoration, and how these concerns affect, or are affected by the fact that the object is made to be used. I'm especially interested in making and decorating functional pots because I feel that the use of those can enrich one's life. I also like the boundaries that function imposes, having some rules makes the aesthetic and technical problem solving more interesting and rewarding.'

After completing her Ceramics Certificate, Patsy Hely went on to obtain her Post Graduate Certificate in 1979, developing methods of making and decorating earthenware tiles and platters. Of her current work she says: 'Most of my work is slipcast. Although the making of moulds is a time consuming process, the production of forms is relatively straightforward. My ideas for decoration and for colour come from various sources and are constantly evolving. Earlier work was an

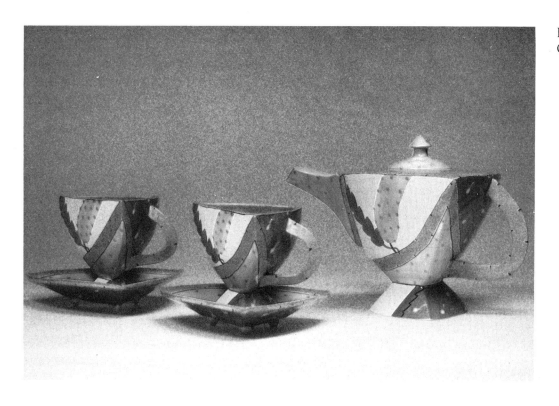

Patsy Hely, teaset, 1984 Mayfair Ceramics Award

attempt at conveying visually the ambience of some of the countries I had visited before becoming a potter. In the past few years I have been coming closer and closer to home in my imagery. I would like my work to be more relevant to today and here and so I have been using my own environment and experiences for inspiration.

'Recently I have been producing my work in editions of 20 and 100, depending on the complexity of the design. Doing this helps to give a structure to my general work practices, yet allows for investigation of new ideas. This continual change and development makes for an interesting and enjoyable work life. It still seems to me a luxury to be able to earn a living from something that I love to do.'

'Viewing the work of Patsy Hely brings multiple pleasures,' wrote Susan Ostling reviewing an exhibition of Hely's work at the Seasons Gallery. 'There are bright and sometimes surprising colour combinations, but also her pieces recall in a sort of way, the pleasures of remembered jokes, parts of stories, poems, ponderings and dreams of exotic things.'[7]

Writing in *The Sydney Morning Herald*, Philippa Gemmell-Smith called Patsy Hely's work 'a delight. Hely, a member of the Glebe-based City Clay workers, makes tea and coffee sets, cups and saucers and plates sets, and jewellery, all as fine as china and revelling in their ornamentation.'[8]

In his review of the 1984 *Mayfair Ceramics Award*, Carl Andrews wrote: 'Patsy Hely was selected by Terence Maloon as the winner of the 1984 Award. She shows two bowls and five tea sets which well represent her joyful and spontaneous approach to form and decoration. She acknowledges the influence of Art Deco but has evolved her own quirky and engaging vocabulary.'[9]

A collaboration with Helen Leitch, has resulted in a number of ceramic murals, made either for commission or exhibition. Patsy Hely wrote for *Pottery in Australia*: 'All my work is decorated. My designs often stem from trying to match a certain colour combination to a certain form or from trying to balance areas of controlled pattern with areas of freer designs. The design for one ceramic mural was based on native coastal flora and another based on underwater life. Many of my recent designs are derived from studies made for murals.'[10]

7 *Patsy Hely*, review by Susan Ostling, *Craft NSW*, 1980

8 *The Sydney Morning Herald*, Phillipa Gemmell-Smith, November, 1985

9 Review of the *Mayfair Ceramics Award* by Carl Andrews, *Pottery in Australia*, Vol. 23/2, 1984

10 *Patsy Hely*, *Pottery in Australia*, Vol. 24/1, 1985

7

THE OBJECT
AS A COMPLETE STATEMENT

Making work that is a unique personal statement, works made not for use but for the pleasure of viewing, is taking the attention of a number of ceramists. These objects are purely decorative and so pertain to applied art. They are complete in themselves and take on the role of display, offering the maker rich new ground in which to explore innovative techniques in ceramic processes. This area of ceramics offers scope for self-expression through the statement of idea, three dimensional structure and harmony of adornment.

Geoffrey Edwards placed Sandra Black within the history of the decorative arts in Australia when he wrote in 1980: 'Although porcelain has, from time to time, been made in Australia by potters including Les Blakebrough, Phyl Dunn, Joy Warren and H.R.Hughan, the particular interest in fragile and often eccentrically-shaped porcelain vessels fostered by English potters such as Mary Rogers and Jacqueline Poncelet, is pursued here mainly by younger and lesser known craftsmen. The small carved and tapering bowls by the West Australian potter, Sandra Black, are examples of this concern. Her delicate, diminutive vessels display a feeling for natural forms but represent a departure from the English potters in the orderly stylisation of bird motifs and the extremes to which the potter takes the device of perforating the thin walls of several of her vessels, thus investing them with a transparency and airiness.'[1]

Porcelain and bone china have special qualities that attract Sandra Black and have influenced her work for several years. These qualities, she says, give her the ability to produce fine wares that have a dense texture suitable for carving, piercing and inlay work, whiteness of ground for brilliant colour quality and translucency which allows for a play of light and shade and gives the work its inner glow and life. Sandra Black continues: 'I have worked around the bowl form for most of my pieces. The forms are usually very simple to allow for more complex and decorated surfaces. Early themes in my work evolved from the landscape, from such things as clouds, shells, water and birds. Later works expressed my interest in science and technology, Art Deco, contemporary jewellery, textiles and so on. My work pattern has been to develop a number of series which I work on simultaneously. The reason for this is that each particular series is very demanding technically so it gives me a chance to do work on several differing techniques during a working week. Series have thus evolved over a number of years rather than months. The longest series is the bird forms, started in 1976 and the pierced bowls started in 1979.'

Sandra Black, *Time Gate,* black bone china, cast and assembled with gold leaf, 1986

1 Geoffrey Edwards, "*Australian Ceramics in the Collection of the National Gallery of Victoria*", in *Pottery in Australia,* Vol. 19/2

Sandra Black, *Pierced Bowl*, cast bone china, pierced and polished, 1986

(*right*) Sandra Black, *Draped Vessel*, cast bone china, wrapped in slip impregnated fabrics, 1986

It was in Western Australia that Sandra Black did her initial training as an art teacher and had her early teaching appointments. Her guest lecturer and workshop teaching programme has been extensive since that time, and both her teaching and her exhibition work has become known throughout Australia. Sandra Black now has her workshop at the Fremantle Art Centre where she is starting a new series using assembled black bone china forms and another group of wrapped and draped vessels.

Meredith Hinchcliffe reviewed Black's work writing: 'Sandra Black works in bone china, a fragile substance. However delicacy and strength fit well together... The delicacy and strength of birds has always been something of a contradiction and this potter draws us into this arena with Escher-like birds joined in flight across the lids of boxes and spheres.'[2]

Penny Smith also fits into the decorative arts idiom. She writes: 'Many potters depend on traditionally accepted values associated with form, function, material

2 Review of Sandra Black's work at Narek Galleries, ACT 1983 entitled "The Delicate Touch" written by Meredith Hinchcliffe

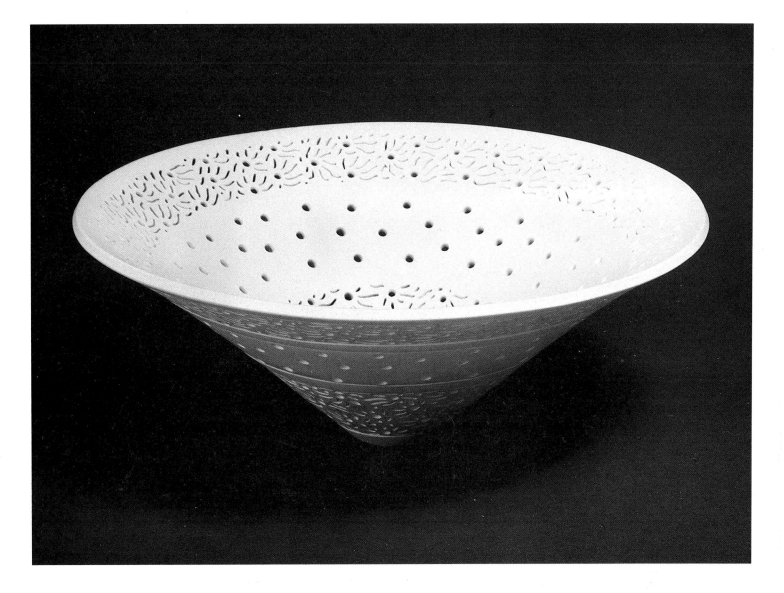

Sandra Black, *Spiked Vase*, bone china, painted

and method, honed to a comfortable precision by years of practice and experience, to produce their work. My own approach has been to challenge these time honoured values. By taking the function of familar objects, the teapot for example, my satisfaction comes from answering the same questions concerning function in as many different ways as possible. The common denominator here being questions relating to containing, carrying, pouring, volume and so on, whilst still retaining the sensuous quality of the clay itself. Sensuality in clay can be defined in numerous ways, through the fluid manipulation of the plastic medium itself frozen by fire, through the richness and depth of glazed surfaces, through texture and form and by combination of all these ways.'

After gaining a Bachelor of Arts degree in Design (Furniture), in Buckinghamshire in 1969, Penny Smith emigrated to Tasmania and decided to pursue a professional life as a potter, establishing her first workshop in 1973. As Head Teacher of the Ceramics Studio, University of Tasmania, Penny Smith has this to say about work ethics: 'Creativity satisfies two basic human needs, the need for personal fulfilment through the pleasure of making and the necessity to communicate to others. The practice of ceramics has shown historically that these two basic requirements have, in part, been satisfied by the making and possessing of pottery, through a universal understanding of the domestic ritual when a constant dialogue is set up between maker and user.'

Penny Smith, slipcast teaset, (from left to right: milk jug, teapot, sugar pot with lid, and three cups), coloured casting slips and multiple combination moulds, clear glaze

(below) Penny Smith, set of individual teapots, slip cast, coloured slips with clear glaze. Combination moulds.

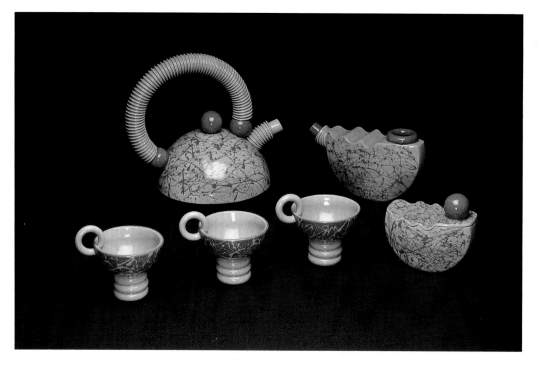

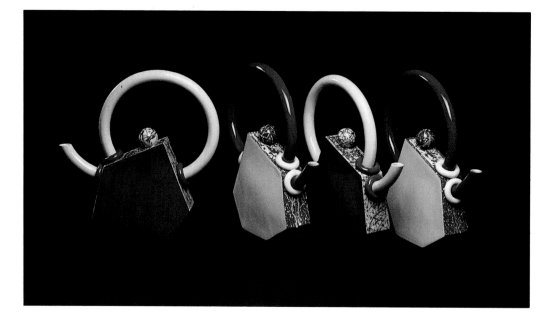

Simone Fraser completed her Diploma of Visual Arts from the Canberra School of Art in 1981. She talks about her work: 'I use clay because it gives me the added dimension of plasticity, allowing intuition free reign. Clay is raw and rough and responsive to impressions. Sometimes those impressions might be an angry thumb or a clenched fist, at other times an image or a thought translated on to the receptive surface. Enormous forces are concentrated on clay pots during the risky processes of the firing when raw rough earth might produce a blush of pastel or a dramatic blaze of colour. Whatever is produced is permanent; pottery has always been the time-capsule of mankind. In my work I am trying to come to grips with that historical link with the great traditions of clay art. Why, I wonder, are classical forms ageless and in being ageless, mysterious?

'I use dry glazes influenced by landscape, rock surfaces and the techniques of long dead civilisations. My inspiration is everything from classical Mediterranean,

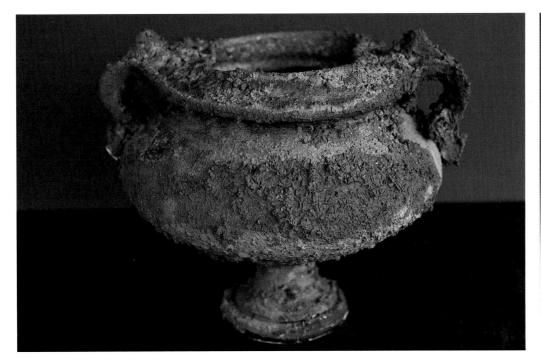

Stephen Benwell, vase, 41 cm/h, 1986

(left) Simone Fraser, dry glazed ceramic form, 29 cm/h

Persian and Chinese art to the encrusted surface of a South Coast pool.'

Stephen Benwell gained his Diploma of Art from the Victorian College of the Arts in 1974 and his Diploma of Education from the Melbourne State College in 1976. After some teaching and travelling and holding several exhibitions in both Melbourne and Sydney, Benwell became a resident artist at the Cité Internationale des Arts in Paris during 1985. He has had two exhibitions in Australia since his return.

In an article on Stephen Benwell in *Craft Australia*, Kay Morrissey wrote: 'Stephen Benwell acknowledges the influence different cultures and styles have had on the development of his work. In the early days it ranged through Rococo, Baroque, Persian to pre-Columbian, and now Pueblo Indian pottery and primitive art as exemplified by Aboriginal work. He has also been influenced by 20th century painting styles such as Matisse and the Abstract Expressionists. Many of Stephen Benwell's pots portray a mixture of both primitive and 20th century art in their mode of surface decoration.'

Carl Andrew reviewed Benwell's work thus: 'Stephen Benwell's group of stoneware vases confirms his standing as one of our most inventive and assured potters who completely integrates functional form with expressive decoration. His lively, witty brushstrokes, flow around his vessels to animate his very personal iconography of landscape and figure references. He has absorbed a wide range of influences from diverse ancient and folk cultures... but these emerge as a highly idiosyncratic language.'[4]

I also wrote about Stephen Benwell in *Pottery in Australia*: 'Stephen has always worked with the handbuilding techniques of coiling, painting pattern directly on to the pot. He has used patterns from primitive pottery, from textiles and from metal objects. He is not concerned whether his pots are used or not, seeing them as complete statements when he has finished them. His work, he says, used to be made in a fairly tight way conforming to the limitations and colours of stoneware. However during his year in Paris, he found his work becoming freer, more sure, more relaxed. Experimenting with earthenware, he found a wider colour range, an interest in texture and a freer attitude to his painting on his pieces.'[5]

3 Article on Stephen Benwell in *Craft Australia*, Autumn, 1983/1 by Kay Morrissey

4 Review of Mayfair Ceramic Award Exhibition by Carl Andrew, *Pottery in Australia*, Vol. 23/2, 1984

5 From an article *Stephen Benwell's Years in Paris*, by Janet Mansfield, *Pottery in Australia*, Vol. 24/4 1985

Stephen Benwell, *Animal*, 19 cm/h, 1986

Terence Maloon reviewed Benwell's work: 'Stephen Benwell is exhibiting some large, irregular coil pots at Robin Gibson's. The *faux-naif* character of the pinched bumpy volumes is emphasised by the graffiti drawings on the polychrome facades. Dubuffet and Paul Klee come to mind as well as folksy majolica vases and figurines. Benwell's glazes resolve into delightful, well considered paintings-in-the-round, where variations of incident and contrast of colour seem to sparkle from every vantage point. It comes as no surprise that the National Galleries of Canberra and Victoria and other regional galleries have snapped up most of the work in this exhibition.'[6]

Susan Banks, reviewing Benwell's exhibition at the Craft Council Gallery, Hobart said: 'One detects in his work the development of a "stream of consciousness" use of imagery. His pictures tell a complex, intensely interesting, surreal story...'[7]

The single object has always been the focus of the work of Jeff Mincham, objects which he regards as unique or individual. This inclination for the one-off piece has gradually dominated his work over the last few years and he produces work to a broad theme that has considerable variation within it. 'Eventually' he says, 'when I come to feel that I have exhausted a particular train of thought I set my mind to something new. However, every once in a while I seem to revisit past styles with the notion that I have something more to add. Over the past four years I have concentrated almost entirely on the vessel and its multitude of forms as a vehicle for

6 Terence Maloon, writing for *The Sydney Morning Herald* in December, 1985, reviewed Stephen Benwell's work at the Robin Gibson Gallery

7 *Craft Australia*, Summer, 1986/4

Stephen Benwell, vase, 41 cm/h, 1986

(left) Stephen Benwell, *Dish with Figure*, 25 cm/h, 1986

aesthetic notions. The basic idea has been to create an object of structural and symbolic power that projects its presence to the viewer. Thus far, there has always been a functional reference in the forms, however this has tended to become progressively obtuse as the forms develop their own unique character.

'The sources for these objects are many and varied and non-specific. I draw on a wide range of ceramic forms from many cultural sources, but only in a vague way; rather, I conceive the forms from my imagination and visual memory. This is, I think, the great advantage of the antipodean potter – being free of the constraints of well established traditions we are free to draw from the whole spectrum of ceramic knowledge without inhibitions. This offers the possibility of contributing to this knowledge with the creation of our own unique genre.'

Jeff Mincham trained as an art teacher and then undertook post graduate studies with Milton Moon at the South Australian School of Art and with Les Blakebrough at the Tasmanian School of Art. He has been active in the crafts movement in Australia over many years and has won numerous awards for his work. Talking about his exhibition work he says: 'Beginning with my first one person exhibition in 1976 in Adelaide my work has encompassed reduced and oxidized stoneware, porcelain, salt glaze, and variations of the *Raku* technique. The four principal groupings have been *Raku* using a landscape theme, *Raku* using traditional jar forms, porcelain using coloured vitreous slip engobes with sgraffito decoration and *Raku* assembled and constructed vessels using copper matt and fumed surfaces.

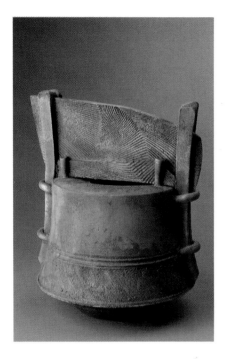

Jeff Mincham *Neoteric Vessel, Raku,* copper matt, 32 cm/h, 1986

(right) Jeff Mincham, bowl form, *Raku,* copper matt, 26 cm/h, 1986

(far right) Jeff Mincham, *Raku vessel,* fumed copper matt, 28 cm/h, 1986

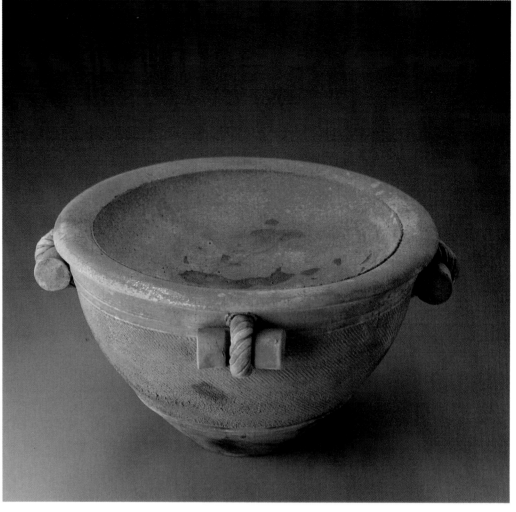

Since 1983, I have been concentrating on the last group. Since 1977 I have always dated my work alongside my signature. My output for the last seven years has numbered between 120 to 200 pieces each year and the works range in size between 12 cms to 60 cms.'

Peter Haynes reviewing Mincham's work at the Crafts Council of the ACT Gallery in 1985 wrote: 'The best works have deceptively simple forms of great sophistication and attraction, their simplicity belying innate sculptural strength and presence. The large *Raku* jars exhibit a solid monumentality of form in their sturdy elegance and their beautifully modulated colours and subtlety defined articulations add to the forms to create strongly considered and creatively manifested wholes... The spontaneity and immediacy of the *Raku* technique has provided inspiration for Jeff Mincham for some years. This inspiration has resulted in this splendidly impressive body of work, an important and aesthetically delightful exhibition.'[8]

There is a sense of completeness about the work of Brett Robertson. With a Post Graduate Diploma from the Royal Melbourne Institute of Technology gained in 1982 and a Graduate Diploma in Education gained in 1983 from the Melbourne College of Advanced Education, Brett Robertson is currently working both from his home studio as well as teaching ceramics and sculpture in the School of Visual and Performing Arts at the Box Hill College of Technical and Further Education. He records that the most significant development period for him so far was his post-graduate year at R.M.I.T. where he had studio space and time to develop a folio of

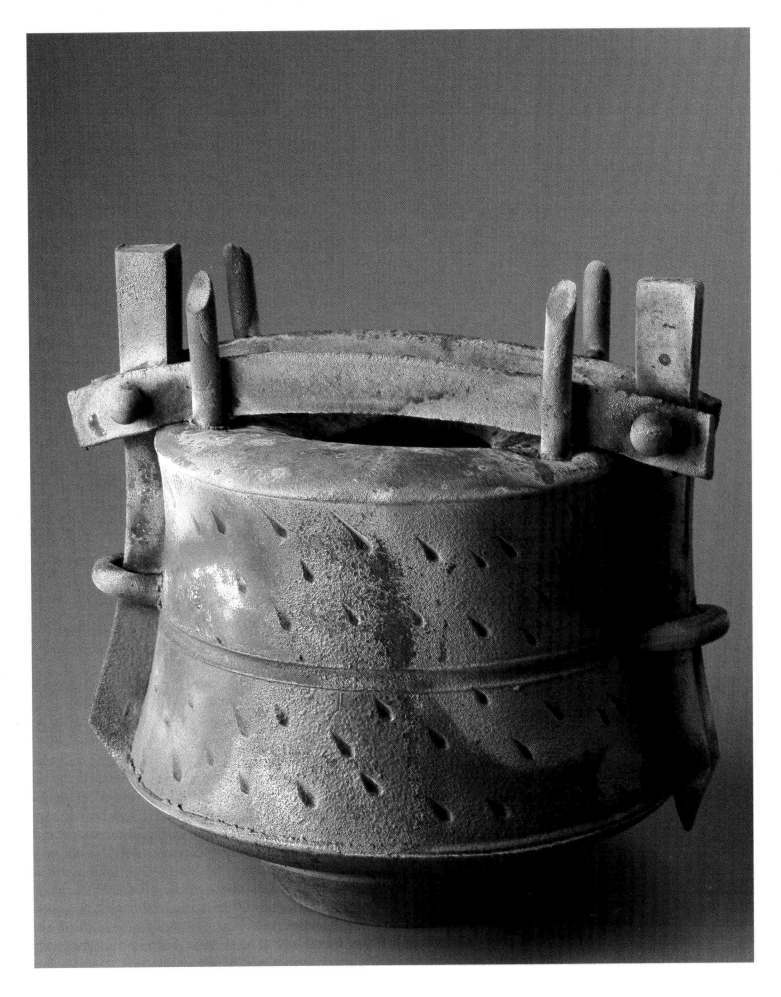

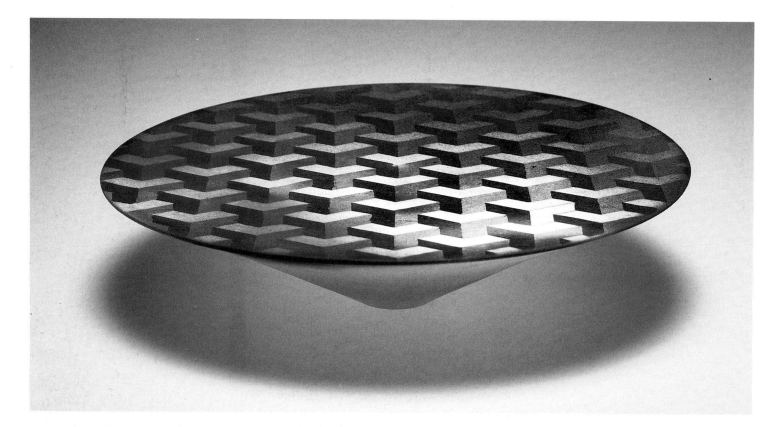

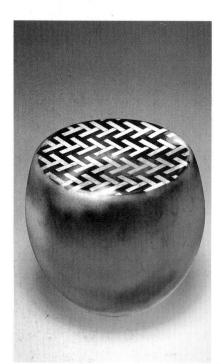

Brett Robertson, thrown porcelain form, sawdust fired with stencil decoration, 20 cm/d, 1986

(top) Brett Robertson, thrown porcelain form, sawdust fired with stencil decoration, 20cm/d, 1986

Freya Povey, *Memories of Hadrian*, 50 cm/h, 1985

9 Terry Owen writing for *The West Australian*: 1986

work. 'Time is a most important consideration in creative processes,' Brett Roberston argues, 'yet we tend to view it more as a deadline rather than as a period to think, enjoy or be still. In my work I had been using smoke effects simply as a means of colouring large sculptural forms, and whereas this technique had been used for economic reasons during my college days I later realised it was underestimated and relatively unexplored. With experimentation I was able to increase the colour range, discover more interesting ways of applying colour and solve the problem of fusing the colour at temperatures low enough to allow penetration by smoke yet give the piece physical strength.

'So my preoccupation with primitive firing techniques, originally developed through necessity, has now become a fascination and a source of continuing development. I have always felt comfortable with geometric, especially cubic, shapes and I have been applying hard edged designs, using masking techniques to the forms. Inspiration for these designs comes mainly from my perception of my surroundings, from nature, from magazines, clothing, architecture, interiors and other contemporary designs. I spend a lot of time building up the patterns; they require careful preplanning. To ensure harmony I use the wheel as a starting point for the development of the shape. Forms need to be crisp and sharp and simple so as not to conflict with the surface patterning. Some recent experiments into other primitive techniques of pit and black firings are suggesting further colouring and decorative possibilities to me and I will continue to explore these. Questioning tradition and established values is a part of my discovery process in ceramics. Curiosity as to what will happen often leads to new ideas and possibilities.'

Freya Povey obtained a Diploma of Fine Art from the Claremont Technical College, Western Australia and in 1980 received a Bachelor of Fine Arts from the South Australian School of Art. Since that time she has been working in South Australia and exhibiting throughout Australia. An exhibition in Sydney in 1986 was reviewed by Terry Owen.[9] 'She is clearly fascinated by the human form. What

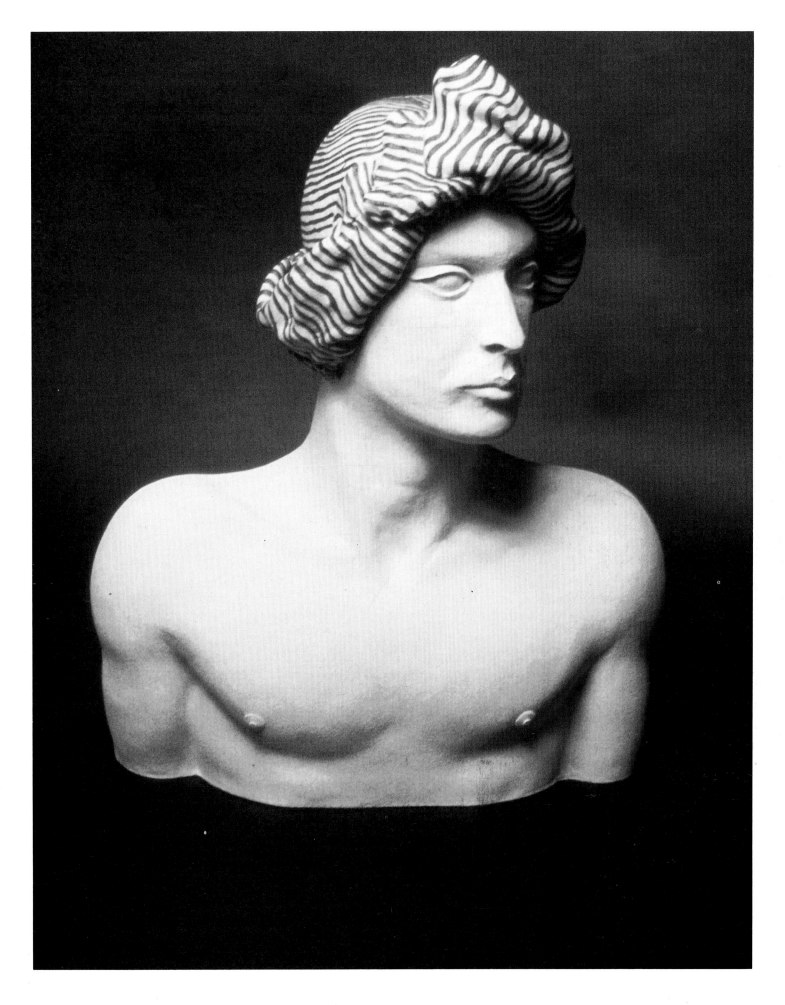

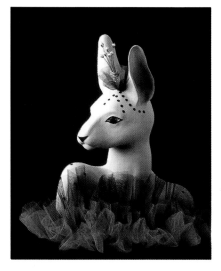

Freya Povey, *Australian Beauty*, 47 cm, 1985

(*right*) Freya Povey, *African Queen*, 80 cm/h, 1985

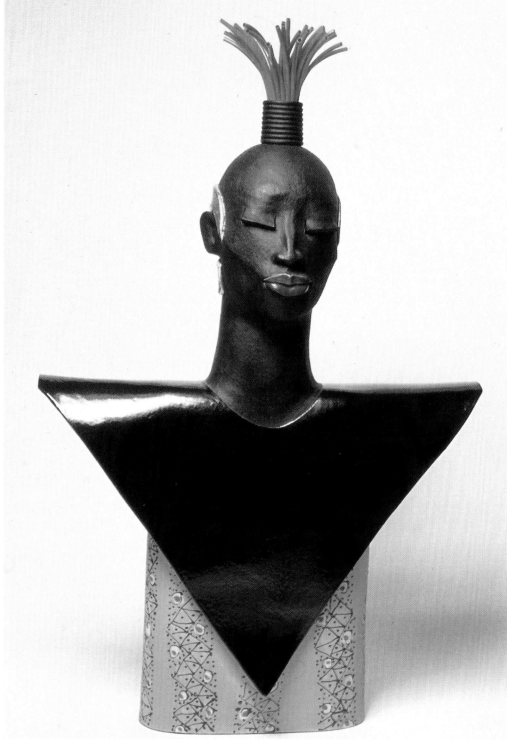

Povey calls her magpie mind collects details of expression and anatomy from friends, from photographs, comics and television.' While she is working on one piece she is usually two or three pieces ahead in her mind, collecting features which will eventually become composite faces. 'Apart from the challenge of having them anatomically correct, the different facial types and features intrigue me and I hope, will continue to do so,' she says. 'Up to now they have had an aura of mystery, the silent smirk or occasional sneer. Next, I hope to make them more animated without appearing clown like.'

Freya Povey, in describing her works says, 'They are purely decorative, non-

esoteric and perhaps in some cases a trifle unnerving... I often start making a face with a plan in mind, then a small piece of clay in a certain area can change the whole feeling of the rest of the features. *Who are you, where did you come from?* It is this feeling of surprise at finding a totally new person that I enjoy and find intriguing.' Collette Snowden described Freya Povey as 'a ceramic artist with a whimsical sense of humour.'[10] Povey agrees that being too serious and too analytical seems to quell a basic creative urge. She says, 'Sometimes, I would rather discover what it is I have been making after it is finished...' Using experiences from her travels for her inspiration, she coils and pressmoulds the clay for her life-size busts of animal or human forms. She colours the works with ceramic stains and glazes. Acrylic and enamel paints are also used plus a variety of other materials such as leather, plastic tubing and so on.

Gail Barwick has established her own workshop following studies at the South Australian College of Advanced Education and two residencies at the Jam Factory Ceramics Workshops in Adelaide, first as a full-time trainee and then as tenant potter. She is well known for her large platters, each platter being in effect a canvas on which she can paint patterns. A love of the large 19th century meat platters from Europe led her to explore this current mode of work . She is attracted to the breadth and generosity of size of the platter form which allows her imagination to run freely as she applies vibrant colours in a seemingly random application of coloured oxides and freehand brushwork. However every line and dot is applied precisely and the patterns form a grid, either parallel or at angles to the rectilinear format.

Lynn Collins, when writing in the *Adelaide Advertiser* about Gail Barwick's work, suggested that it was the close inspection of the variations in the ornamentation that provided a rewarding experience, the similarities and the differences in the

Dianne Peach, *Shadow Box*, slip-cast porcelain, 10 x 5 x 10 cm

(left) Gail Barwick, earthenware platter, 50 x 40 cm, 1986

10 *Freya Povey* by Collette Snowden, *Pottery in Australia*, Vol. 24/4, 1985

(*top*) Dianne Peach, porcelain fan, 25
x 5 x 23 cm, slab built in slip-cast base

Dianne Peach, cube container, 11 cm,
slip-cast porcelain

Dianne Peach, square teapot, 11 x 11 x 6 cm

patterns. Gail Barwick acknowledges a variety of inspiration for her work: textile design, Oriental rugs, traditional tiles and 16th century majolica. These multi-coded references, she believes, echo the Australian cultural mosiac.

The work of Dianne Peach is mostly handbuilt with an emphasis on visual appeal. 'Coming from a functional/utilitarian background, I am constantly striving for a balance between form and function even though my work is approaching a more abstract orientation. Handbuilding as a means of production fulfils my love of making things and the purchase of a mechanical slab roller some years ago was the catalyst which brought about a radical change in my studio output.' It was at this point that Dianne Peach began making square slab pots instead of the traditional round pots. She began to look to fundamental forms for direction, cubes and pyramids for example, and was able to use her drawing skills in combination with the forms to develop a unique and personal style.

After studying ceramics at the Central Technical College in Brisbane, Dianne Peach established her own production studio and began teaching in 1966. In her work as a full time ceramic artist, slip casting techniques also play an important part. Basic moulds with interchangeable parts allow for many and varied cast shapes which can be cut, altered or added to. She says: 'This is the method which I use to make teapots. The functional elements of a teapot, spout, handle and lid become parts of a simple geometric volume. My *Jewel Boxes* grew out of a search for a special piece for a special occasion, and were the result of combining the pyramid, a difficult lidded shape on its own, with a square box form as its base. This formal structure seemed to require formal decoration, and so was born the precise and rigid geometric decoration which has dominated my work of recent years. Areas of colour are controlled within the limits of contact paper stencils. Commercially prepared stains and underglazes in a 50/50 kaolin and whiting glaze mixture are airbrushed on the bisque fired ware. Many hours are spent sanding, refining and polishing, particularly the unglazed pieces which are mainly slip cast in porcelain.'

Dianne Peach's work has been called 'precise, clean and smooth with a perfection of surface and simplicity and beauty of form.'[11] She describes the work

11 From the catalogue *The Queensland Gift Exhibition*, 1985

Dianne Peach, *Jewel Box*, slab-built
box with slip-cast lid, 22 x 22 x 25 cm
(*right*) Sony Manning, plate, 28 cm/d

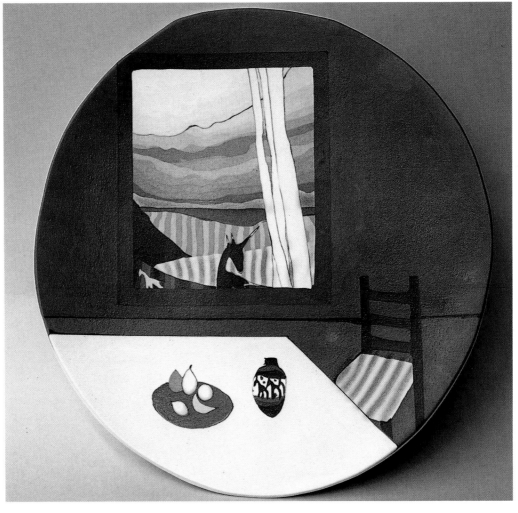

12 Review of work in "Different Approaches" at
Lake Russell Gallery, Coffs Harbour, by John
Elsegood, *Pottery in Australia*, Vol 23/2 1984.

13 Review of work shown in exhibition entitled
The Delicate Touch at Narek Galleries, ACT
1983 written by Meredith Hinchcliffe for *The
Canberra Times*

14 Peter Haynes reviewing *Delicate Touch II* in
The Canberra Times, June 1985

15 David Seibert in the article *Three Contempor-
ary Clayworkers*, in *Pottery in Australia*, Vol.
25/1, 1986

involved: 'The translucent porcelain fans and screens are extremely time
consuming and because of their vulnerability throughout the making process, their
survival alone gives me great satisfaction. Working with translucent clay bodies,
where I design pieces to display the effects of light through the clay, is a joy for me.
The perforated screens and boxes are a natural progression of this play of thinness
and thickness.'

The work of Dianne Peach has been described by John Elsegood[12] as 'concerned
with the precision of cast planes and edges... her attention to detail and the
architectural nature of her forms' and by Meredith Hinchcliffe[13] as 'delicate, well
crafted, fragile and sensitive.' Peter Haynes[14] used such phrases as 'the decoration
flows gently over the surface, subtly underlining the shape,' 'elegant spatial rhythm
through contrasts of diagonals,' and referring to some pieces as having 'an innate
architectural quality' while retaining the 'intimacy of the materials'.

David Seibert states: 'Dianne Peach's conceptually strong, technically excellent
pieces thoroughly demonstrate her mature command of clay. She has an
uncompromising attitiude toward her work, allowing only those pieces that fulfil
the high standards she sets to leave the studio.'[15]

Sony Manning had originally planned to become a painter but, as she says, 'Clay
has given me the freedom to express more accurately my visions and thoughts.'
Gaining a Diploma of Fine Art from the Royal Melbourne Institute of Technology
in 1978, her ceramic work is now in many major collections in Australia and New
Zealand. She describes her working methods: 'I work with techniques of inlay, a
process of putting different coloured clays together. Colours, and the way they work

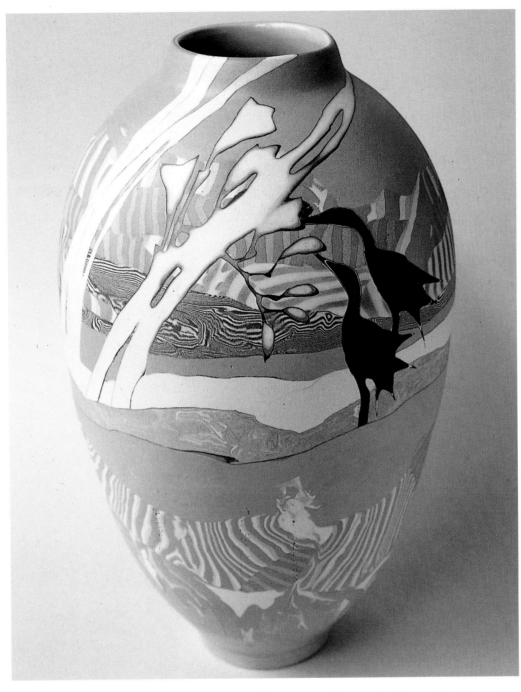

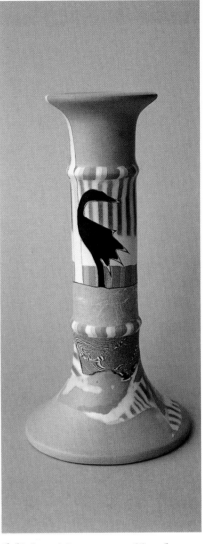

(left) Sony Manning, jar, 32cm/h

Sony Manning, candlestick, one of a pair, 19 cm/h

together is important to me. I use fine, creamy porcelainous bodies and add metallic oxides, developed through trial and error, to achieve a palette of colour, all of which will mature at 1260 degrees centigrade. The form is first cast or handbuilt then inlaid with combinations of coloured clays. Landscape shapes then other figurative elements are carved out through this and inlaid again. Putting coloured clays together presents many problems which have taken time to solve. Clay is a responsive material but can also be unforgiving in the fire. I still lose many pieces. I prefer to work with simple bottle and cylinder forms. They are glazed only on the inside. The vessel form has a cultural significance to me and I use it only as a reference to recognised function.'

Sony Manning uses imagery which has personal reference. 'Sometimes it is a celebration of line and movement and graphic composition and sometimes a preference for a lonely and remote land and the spirits within it.' The landscape has become a form of autobiography. She draws on memories of mountains, an interest

Victoria Howlett, *Water Lillies*, slab platter, 35 x 40 cm

in the formation of land masses and uses animal figures as symbols of life and movement. 'The animals do not belong to any particular species, but composite shapes which I edit and abstract. The characteristics and proportions of the animals and birds or the thickness of a tree trunk can date a piece of my work. Some motifs are consistently used. I have started working with interiors as subject matter and I have used a two-dimensional plane, using images of *still-life* and windows through which typical landforms and animals of my other work can be seen.'

Ancient Egyptian glass making techniques where coloured glass rods were fused together and slices cut through as cross-sections were the original inspiration for the techniques used by Sony Manning. It is the adaptation and abstraction, combined with the use of personal imagery and expression, that makes her work autobiographical and contemporary.

Bryan Trueman has written: 'Sony Manning has established a well respected reputation for her continued development of low fired porcelain decorated with inlaid areas of coloured clays... Sony Manning's work contains strong elements of inventiveness and a feeling for design.'[16]

Victoria Howlett is interested in colour, or more specifically, the act of applying colour. For her the enjoyment of making a piece is as important as the finished product. She says: 'It's impossible for me to make a successful piece if I am not totally enjoying the creative process. As a full time professional potter dependent on producing work that I'm satisfied with, I've trained and disciplined myself to do just that, each working day, developing and practising being fluent in my technical skills.' After gaining a Diploma in Ceramics from the Royal Melbourne Institute of Technology in 1965, and doing some travelling and some teaching, Victoria Howlett established a studio in Melbourne and began potting and drawing full time, producing individual sculptural and decorative items.

'There is little glamour in being an artist' says Victoria Howlett, 'It is mainly hard work and how to achieve another good day of work. There are so many set-backs that can hamper one's goal. Being a potter is like being a skate board rider, it is not just being able to ride or throw, but it is the ability to get out of difficulties with ease that really counts... I rarely make a single piece in isolation, rather I work in a

1986 *Imagemakers* by Bryan Trueman, *Pottery in Australia*, Vol. 21/2, 1982

Victoria Howlett, *Red Square*, slab platter, 25 x 35 cm

series. Each series evolves into the next so that there is an ongoing thread of development and each idea holds the germ of the next idea. Forms or colours or particular calligraphic strokes will appear repeatedly throughout my work and I will use these in various ways with varying degrees of emphasis. In this way I have developed my personal style and I think most artists work in this thematic way. This is a continual striving for the most satisfying execution of a particular notation and the notation appears in a variety of ways, according to the skills and the mood of any time. I never reach the *final solution* of the imagery and really there is no right way. If one did find it there would be no need to keep working. One would just have to launch out on a whole new theme, or not work at all.'

Victoria Howlett's exhibition at the Potters Gallery, Sydney, in August, 1985 was reviewed by Pam Thorne: 'She is concerned with the pot as canvas on which to deploy her designs. Her themes for this exhibition are the patterns of a forest in springtime which she evokes with a lyrical employment of daubs of delphinium blue, soft violets and pinks. In this, her pieces stand midway between realistic depiction and the study of pattern for its own sake. The balance is just right.'[17] Johanna Fischbein, reviewing the same exhibition in the same journal had this to say: 'All these works have a lively and spontaneous quality and do not seem laboured. The decoration is often in the form of repeating patterns but with the appearance of a watercolour. Irregularity of shape and uneven surfaces give each item the appeal of the quirky and idiosyncratic. In fact they could almost be products of nature.'

17 Victoria Howlett, Potters Gallery, Sydney, August, 1985. Review by Pam Thorne for *Craft Australia*, Summer 1985/4

8

CERAMICS AS SOCIAL COMMENTARY

Bernard Sahm's early involvement with art was in painting with a heavy bias towards social realism, mostly commenting on the social ills and the political hypocrisy of the day. 'To a large extent this bias is still with me,' he says, 'albeit somewhat tempered with humour and experience. Looking at the full spectrum of works in ceramics one sees those which are visually satisfying, either decorative or functional works which make a statement regarding concepts of a political, social, philosophical or personal nature. All these areas are equally valid and variously attract either specialist practitioners or others who move across the boundaries when a challenge arises. One could find the function and aesthetics of a plant container, for example, or a visual expression of the notion of *being,* equally absorbing. This could also be interpreted as a conflict of interests; one dissipating the other although I tend to find that operating in various areas keeps one from becoming repetitious or stale.'

Bernard Sahm studied at East Sydney Technical College gaining a Ceramics Certificate and an A.S.T.C. in Sculpture. He had practical training in both commercial and studio potteries in Australia, Germany and in the Crowan Pottery of Harry and May Davis in England. 'I have never felt happy however,' he says, 'working in the restrictive mode of say the Leach or Japanese school. I have always considered myself an Australian with the whole world to draw from, I have preferred to go my own way. After my initial training and experience in Australia in the early fifties, there was still the feeling that this was not the full story, somehow there had to be more, particularly since at that time there was no significant pottery tradition in Australia. In order to feel adequately professional as a potter I made a study trip to Europe visiting as many potteries, museums and colleges as possible, and working in both Germany and England. Apart from learning techniques and skills the important lesson I learnt was that everyone everywhere seemed to have the same worries and problems and that there was no need to feel isolated in Australia.'

'To interpret and reveal is art' wrote Wayne Higby in his essay *Craft as Attitude,* [1] 'The rest is politics. . . . Artists must seek for the ideal in what they make.' Quoting Kay Larson, he went on 'A good artist is someone with a clear position and a strong means of expressing it.'

Maria Kuczynska is such an artist. Internationally renowned, Polish born, Maria Kuczynska is currently working in Australia. Writing about her work, Peter Haynes

Bernard Sahm, *Circa 19?,* mixed media, 70 cm/h, 1984

Bernard Sahm, *That Which is Within is Even as Without,* lidded urn, 40 cm/h, 1985

1 See *Pottery in Australia,* Vol. 25/2, 1986

Maria Kuczynska, *Helmet*, porcelain, 18 cm/h, 1982

(right) Maria Kuczynska, *Guard*, porcelain, 18 cm/h, 1983

said: 'Echoes of ancient Greece, the Middle Ages and the sensuous serenity of the Oriental world inform and influence her work. Thematically, the condition of man in the contemporary world – the faceless, universal figure enmeshed in a fate determined by an unnamed external force – continues to supply and incite forcefully beautiful images, powerful in their impact as statements of the human condition and compelling in their attraction as aesthetic entities.

'The artist selects and edits her sources with that sensitive awareness to her own aesthetic and thematic concerns which should be the hallmark of all good art... The evocation of history's continuing flow and the insistence on man's transience, both of these coupled with the implied concept of the importance of the individual's contribution (in this case the artist's own contribution) attests to the importance of the artist as commentator, to the continuing importance of art as the witness to, judge of, participator in, the continuum of life.'[2]

In the catalogue introduction for an exhibition of Maria Kuczynska's work, Robert Bell wrote: 'The presence of an artist of the stature of Maria Kuczynska in Australia has meant that we have access to experience and ideas usually not found in this country. Her art deals with the emotions, heroic visions of the human form drifting from history into the present, and past us into the future. A classicism pervades Maria Kuczynska's work, from the smallest head forms to the largest, bound and freestanding figures. Subtle historical references guide our experience of her works but do not imprison them in a rigid historical frame; rather they remind us of the timelessness of the human condition.'

Man's impact on his environment has remained the source of imagery, and a dominant force in the work of Vincent McGrath for some years. Currently Head of the School of Art at the Tasmanian State Institute of Technology in Launceston, Vincent McGrath received his Diploma of Art and Fellowship Diploma from the

2 *Maria Kuczynska, Ceramic Sculpture,* by Peter Haynes, *Pottery in Australia,* Vol. 24/3, 1985

Vincent McGrath, *In Search of the Kookaburra*, 1.2 m x 1.2 m x 80 cm, 1985

Royal Melbourne Institue of Technology. He gained his Master of Fine Arts from the University of Puget Sound in Washington. Vincent McGrath was Head of the Ceramics Department at the Darwin Community College for several years. Receiving many awards for his work, McGrath has exhibited widely, undertaken commissions for murals and other ceramic work, and is represented in collections in Australia and overseas. Influenced by both natural and the man-made environment, Vincent McGrath has this to say: ' The imagery with which I work has been closely associated with the Northern Australian land and townscapes. It is the result of a reaction to the harsh climate, a respectful attitude for nature's survival and a study of the means man uses in asserting a long-term influence on the land. Since living in Tasmania my attention has been drawn to the isolated regions of this State, particularly to the mining areas where man has left an unmistakeable mark on the landscape. It is not the act of mining but rather the desecration that is my primary concern. Mullock heaps, wrecked vehicles, dilapidated buildings and twisted structures are all symbolic of a past presence. They are a testament to a cause that abruptly finished, leaving no alternative but to yield to the forces of nature, but at the same time scarring it.'

Robert Ikin writes about Vincent McGrath: 'In the time Vincent McGrath lived in Darwin he allowed his environment to become an integral part of his work. An exhibition in May 1981 at the Museum and Art Galleries of the Northern Territory showed twenty eight draped free form slabbed, platter forms, approximately 70 cm in diameter, decorated very vividly with Northern Territory imagery. The drawings in clay show windswept palm trees, abstracted monoliths reminiscent of ant hills, rainfall, flood plains, overhead fans, and rock formations; rendered in underglaze stain, oxides and glazes applied through etching, airbrush and brush. There is a dichotomy in these forms between the functional form[3] (platter) and the decorative

3 *Vincent McGrath* by Robert Ikin, *Pottery in Australia*, Vol. 20/2, 1981

Vincent McGrath, *East Point and a Memory I,* 1.2m x 1m x 60cm

or graphic aspect of the piece, as there is between the idea of man and nature.'

In a review of Vincent McGrath at the Cartwright Street Gallery, Vancouver, in 1982, Diane Carr, Director of the Gallery, writes of McGrath's landscape pieces: 'McGrath has evolved a symbolic imagery which he uses narratively. These symbols, a visual shorthand, float across the picture plane like objects on a stage or, as in a dream, on the surface of the mind.' She writes also that colour is used symbolically rather than for its decorative possibilities, green representing the fertility and abundance that comes with the rainy season, and with it the fulfilment of hope.

Vincent McGrath participated in the International Ceramics Exhibition in Toronto, Canada in 1985, one of ten ceramists from around the world selected to exhibit. McGrath said of his work at the time: 'The pieces for the Art Gallery at Harbourfront, Toronto, take further my concerns for the role man plays on the surface of the earth.' Trish Armstrong reviewed this exhibition: 'Vincent McGrath's work is about groups of people who pillage and destroy the environment for temporary rewards. It could be argued that the influences in McGrath's work are essentially Australian, the elements being a Northern Territory setting and the prodigious effect it has on man and his technological inventions. However, although the experience is an Australian one, the message is understood universally, that whatever act of aggression is perpetrated by man on the environment, the ultimate force of nature will eventually overcome it, yet it will never be quite the same again.'[4]

4 *Vincent McGrath at Dragonstone* by Trish Armstrong, *Pottery in Australia,* Vol. 25/3, 1986

Alan Watt, landscape form, *Along the Edge* series

Feeling public acceptance ought not to restrict an artist to an established style or method, Vincent McGrath says: 'I consider my work as in a state of flux. It is a continual progression of conceptual thinking rather than a change in method or expressive vocabulary. The means by which the statement is made is always changing to suit the expression, whether it be low fire, highfire, *Raku* or large installation techniques. I am never dictated by a process just because I am comfortable with it'.

Comment on the beauty of the unspoiled natural environment is also an aspect of the work of Alan Watt. 'Alan Watt's forms continue his concern with abstracted elements of the landscape.' Peter Emmett was reviewing the *Faenza 1983* Exhibition.[5] 'The fragment sheets of clay placed on obtuse white boxes work on several levels. As formalist works, the deliberate placement of black fragments on a white base creates a set of relationships that change as the work is viewed. The fragmented sheets also explore images of landform – inclines, plateaux, escarpments, spurs with encrusted surfaces and crevices. In detail the ceramic sheets have beautiful and subtle tonal and textured variations – matt to lustre with touches of burnished bronze. The total work has a strong sense of form, the ceramic components having a weighted quality, sitting heavily on the box and pouring over the edges.'

Alan Watt received his Diploma of Art (Ceramics) from the Royal Melbourne Institute of Technology in 1967. He also received his Fellowship Diploma in Ceramics from the same Institute. He is currently Head of Ceramics at the

5 *Faenza 1983, Review by Peter Emmett for Craft Australia, 1983/2*

Maggie McCormick, *Women*

(right) Maggie McCormick, *Contemplative Space, Decision Maker*, slip-cast, 50 cm/h

Canberra School of Art. The influence of the environment has been dominant in his work for some time. In the catalogue for the exhibition *Recent Ceramics* which toured overseas in 1980-81, he stated: 'The miniscule tracery of seashore patterns, often random, sometimes ordered, have always evoked visions of abstracted landscape.'

Maggie McCormick is an artist who aims to 'reflect, comment on and influence' her environment. She sees her work as social comment, expressing the personal and communal dilemma of our existence. 'On the one hand there is the strength,

Toni Warburton
Marine Jardinaire no. 3
Terracotta painted with slips and
underglaze colours 65 x 65 cm.
Collection National Gallery of
Victoria

vitality and energy of life and on the other hand there is the constant overshadowing of this by the possibility of annihilation by warfare, the precariousness of everyday living.' Using humour and making gentle prods at the way we behave, McCormick has a strong decorative element in her work. The pieces also convey a sense and confidence in herself as a woman. 'My ideas and work have been influenced by women's culture,' she says.

Widely travelled and exhibiting both in Australia and overseas, she draws on experiences in the U.S.A., South America and Europe. She hopes, she says, to be always moving in herself and in her work, 'in a state of transition, exploring, striving. I hope never to have arrived. Women's culture has been largely disregarded in the past. I hope my work will be valued for this element and also for its inherent qualities of beauty and vitality.'

In an exhibition at the Devise Gallery in November, 1985, Maggie McCormick showed the two major themes which are currently dominant in her work, herself as a woman in society and the threat to us all of nuclear warfare. She wrote at that time: 'My answer was to create two distinct installations/spaces/environments... a celebratory space and a contemplative space.'[6] Within each of these spaces, pieces were framed individually. The celebratory piece applauds the strength of women, full of colour and hope, while the contemplative space is filled by people who questioned the way things are.

The work of Toni Warburton has attracted attention for its comment on social and environmental issues. Using the vessel form as a basis for her satire, she coil builds terracotta urns and jardinières, modelling the surfaces with symbolic imagery. In 1981 she wrote: 'I am interested in the dynamic interplay created between the forms on the surface ... At present my decorative themes are derived from drawings and the study of marine life.'[7] These studies as well as her social consciousness were evident in her work for the *Mayfair Ceramic Award Show*, as Carl Andrews wrote:[8] 'Toni Warburton is deeply involved with marine images and her most successful works integrate their forms with their encrustations of flotsam and beach litter – ropes, shells, feathers, bones and... pieces of sea-worn plastic bottles and rubber thongs.'

6 See *Pottery in Australia*, Vol. 25/3, 1986

7 *Inner City Clayworkers Co-operative* in *Pottery in Australia*, Vol. 20/1, 1981

8 Review of *Mayfair Ceramic Award Show* by Carl Andrews *Pottery in Australia*, Vol. 23/2, 1984

Toni Warburton
Allegorical Contraption
Earthenware painted with stains,
vitrified slips and metallic glazes
50/h x 6 cm *Photograph*: Shayne Higson

Toni Warburton
Theatre of the Xanthorrhea
earthenware painted with vitrified slips
65 x 65 cm.
Perce Tucker Collection, Townsville

9 *Sex Politics and Religion, an Aspect of Pottery Today*, by John McPhee, *Pottery in Australia*, Vol. 24/1, 1985

10 *Craft Residencies, Griffith University* by Margaret Bonnin, *Pottery in Australia*, Vol. 25/1, 1985

Commenting on her work at the Mori Gallery in 1984, she states: 'These objects refer to the human habit of souveniring things to remind them of a particular place. Things collected, stones, shells, are contained by the object and brings it to completion. Rather than attempting to imitate natural forms, in these pieces they are referred to pictorially, or through pattern in an exploration of the aesthetic of the terracotta medium itself.'

John McPhee wrote in the article *Sex, Politics and Religion, an Aspect of Pottery Today*: 'Religious and secular imagery is mixed in Toni Warburton's *Atoll Reliquary, No. 6 1984*. In this piece... there is a boldness of the shape and strength of the message conveyed. Atop the apex of the reliquary are a sea urchin, a starfish and a container of crystal clear water (made of prisms of glass). Inside the reliquary are two delicately modelled frangipani flowers. These evocatively surviving reminders or remainders of a tropical atoll rest in the otherwise empty box supported by four columns of coral. Sinisterly, these rise from a drum whose poorly fitting lid is marked to show it is a nuclear waste container.'[9]

Toni Warburton was invited to participate in a craft residency at the Griffith University in Queensland in 1985, to experiment with a possible synthesis between individual studio practice and a collective arts experience in a community project. Margaret Bonnin wrote: 'Toni Warburton's work reflects the ironic contrasts between the freshness and the innocence of natural forms and the ominous intensity of sophisticated urban and industrial concerns.'[10] During the residency Toni Warburton completed a commission for the Australian National Gallery, and produced work for a series of exhibitions, including *Perspecta 1985*.

Social commentary in the form of story telling is the approach taken by Graham

Graham Oldroyd, *The Figure of Science searching for his own heart*, 90 x 20 cm

(left) Graham Oldroyd, *In Vitro Annunciation*, 54 x 58 cm

Oldroyd. 'Most of Graham Oldroyd's recent work is sculptural, depicting human stories or myths. The pieces resemble Passion Plays, tales of human tragedy or joy. The figures portray pathos and also humour and the surfaces are deliberately aged to express Oldroyd's admiration for ancient works and the lasting spirit they bequeath us.' Kim Oldroyd continues about Graham Oldroyd: 'This development satisfied his desire to communicate his ideas with ceramic work.' 'Ideas should be the beginning of a work,' says Graham Oldroyd, 'rather than the simple interest in materials. Long standing human dilemmas, love, the soul, spiritual and human absurdity and incongruity are the subjects of my sculptures. A painter will lay down an image and then next day cover it over and layer it. Composition is important in my work this way. I build the pieces gradually, constructing, composing and layering the ideas. Eventually you get to a point where the piece will finish itself, the composition and the materials take over.'

Graham Oldroyd completed the Ceramics Certificate Course at East Sydney Technical College before studying at the Canberra Technical College in 1974. Currently he is Head of the Division of Ceramics for the Department of Technical and Further Education in New South Wales. Although working for many years on the surface glazes to complement his forms, Graham Oldroyd believes he has departed from the craft tradition in his approach to his materials. 'I am more interested in the accidents that transform the materials and the form,' he says. 'In the search for reflection and light I will try to echo lustre by pouring molten glass on to a piece, or, to express age, I use chemicals to alter the surface. I use twisted kiln elements, old metal pieces, fragments from earlier work and intertwine all these materials. The life of the piece vibrates and echoes between these elements.'

Gudrun Klix, *Burial Piece II*, 1985

In 1982 the painter, Michael Ramsden and Graham Oldroyd began producing work together. Over the last five years, this collaboration has strengthened and since 1986, they have been working full-time together to produce a commissioned art work for the New Parliament House in Canberra. While still continuing to produce their individual work, they also see the collaboration as a life-long process, and one which will occupy a part of their creative output each year.

Susanna Short, writing about Oldroyd's exhibition in 1985 says, 'There is no lack of inventiveness in the ceramic figures of Graham Oldroyd at the Mori Gallery. His exhibition is divided into ceramic pots, which are earthy and look quite ancient, and small ceramic figures which have the connotations of the sea and are purely fanciful. These figures evoke an Aegean or Mediterranean world and are an odd mixture of pagan and Christian references. With their molten, sinuous forms and contrasting slippery, smooth surfaces, they show the extreme flexibility of clay as a medium. In the hands of such an imaginative artist as Oldroyd, clay becomes an expressive and emotive vehicle.'[11]

Gudrun Klix received her Master of Fine Arts from the University of Wisconsin in Madison, in 1979, after gaining a Bachelor of Arts in Education and a Masters of Arts in German Literature also in the United States. With wide teaching experience both in the States and Australia, she is currently Senior Lecturer and Head of the Ceramics Department at the Sydney College of the Arts. Gudrun Klix has contributed work to a considerable number of exhibitions since her arrival in Australia in 1981 and has been involved in professional organisations and lectured throughout Australia. Jonathon Holmes wrote of her work in 1982: 'This first work of Gudrun Klix since her arrival in Australia addresses itself to a range of sculptural concerns which are clearly well expressed in clay; for some time now she has been creating slip-cast clay *rocks* . . . From a purely physical point of view, clay is an inorganic material formed from rock and Klix has spoken of the aptness of thus rendering her rock forms in clay. . . The installation is a strong formal statement which carries with it a strong personal philosophical position, one which posits the view that humankind will quickly destroy itself unless it learns to work in harmony with nature.'[12] Gudrun Klix agrees: 'I am concerned with how we treat our planet. We are only here for one fraction of a second in geological time and yet our impact, especially that of the present generation, is tremendous in its destructive power. Every day thousands of acres of prime forests are destroyed, the ocean becomes irreversibly more polluted and animal and plant species are wiped out. I am concerned for the future generations who will inherit an earth denuded of wildlife and beauty. Through my work I wish to evoke a spiritual unity with nature as an alternative to the present situation, to question what we are doing to our environment and to suggest the ultimate consequences as I see them.'

The work of Gudrun Klix was described by Susan Malm in 1983: 'Gudrun Klix deals with clay in a way which could be described as *environmental* or *ecological*. In some pieces, Klix has combined these symbols (of earth and clay's origins in the earth) with man-made elements; in one piece the rocks swarmed over a step ladder, whilst in another, two derelict chairs were overtaken by the forms, in both works, Klix was hinting at the impermanence of our structures, and therefore at their lack of spiritual value.'[13]

A ceramic and mixed media installation entitled *Path/Edge Mind/Edge* was shown at the Gryphon Gallery and later at Festival Gallery Centre, Adelaide in 1984. Her work in the United States had used elements from her environment, and she now turned to a new environment for inspiration, using a track on Mount Wellington, Tasmania, to focus on the symbolic content of the imagery of the trail or path. She

11 Review of Graham Oldroyd by Susanna Short, *The Sydney Morning Herald*, 1985

12 Catalogue entry by Jonathon Holmes from the exhibition "New Art", University of Tasmania Fine Arts Gallery, February, 1982

13 From the exhibition catalogue *Ceramics – Objects and Figures*, University of Tasmania Fine Arts Gallery, July 1983

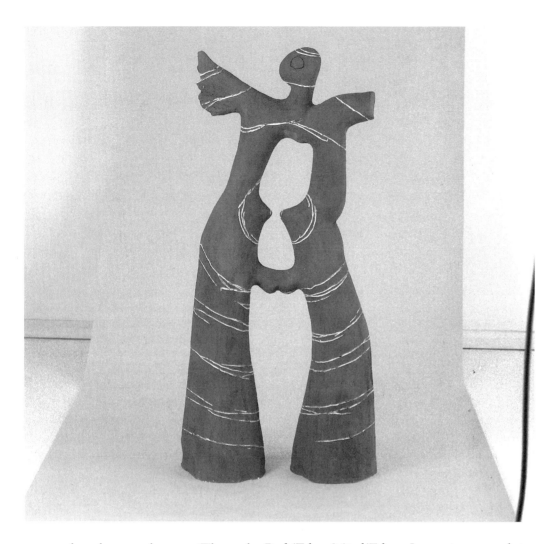

Gudrun Klix *Winged Figure*, handbuilt, 1.2 m x 60 cm x 25 cm, 1986

wrote for the catalogue: 'Through *Path/Edge Mind/Edge*, I am interested in exploring the metaphorical content of our path/life.' John Teschendorff reviewed the exhibition: 'The central focus, an impressive, finely articulated segmented cast, caught the imagination and satisfied the most demanding viewer'.[14]

In the exhibition *Impulse and Form*, shown at the Art Gallery of Western Australia in 1986, Gudrun Klix again showed rock forms and chairs, writing 'The chair has become a symbolic element representing the presence of the self, an observer of one's life.' Symbols of travelling, observing, of decay and rebirth are elements of Klix's work. The fragility of nature in the hands of humans, and the fragility of mankind itself are represented with both warnings and hopes for the future.

'Most recently' writes Gudrun Klix, 'my work has taken a turn away from the installations moving towards singular objects that tend toward the figurative. In these, the concern is still with the environment and combined with the human presence in either its symbolic or literal form. The first of these, a series of *Chairs*, was inspired by a trip to the Northern Territory where I spent four weeks studying Aboriginal carvings and rock art. What impressed me was the degree to which the art/spiritual world was integrated with the land, the people and the belief systems through millennia of time. In these pieces I want to express our dependence on the earth as well as our need for spiritual wholeness. I do not see these as separate issues, but rather that one grows out of the other and comes together in every living form. So the chair, which earlier I had been using in a detached symbolic sense, comes to life, growing, yet tied to the earth through dependence for sustenance.'

14 *Path Edge/Mind Edge*, review by John Teschendorff, *Pottery in Australia*, Vol. 23/2, 1984

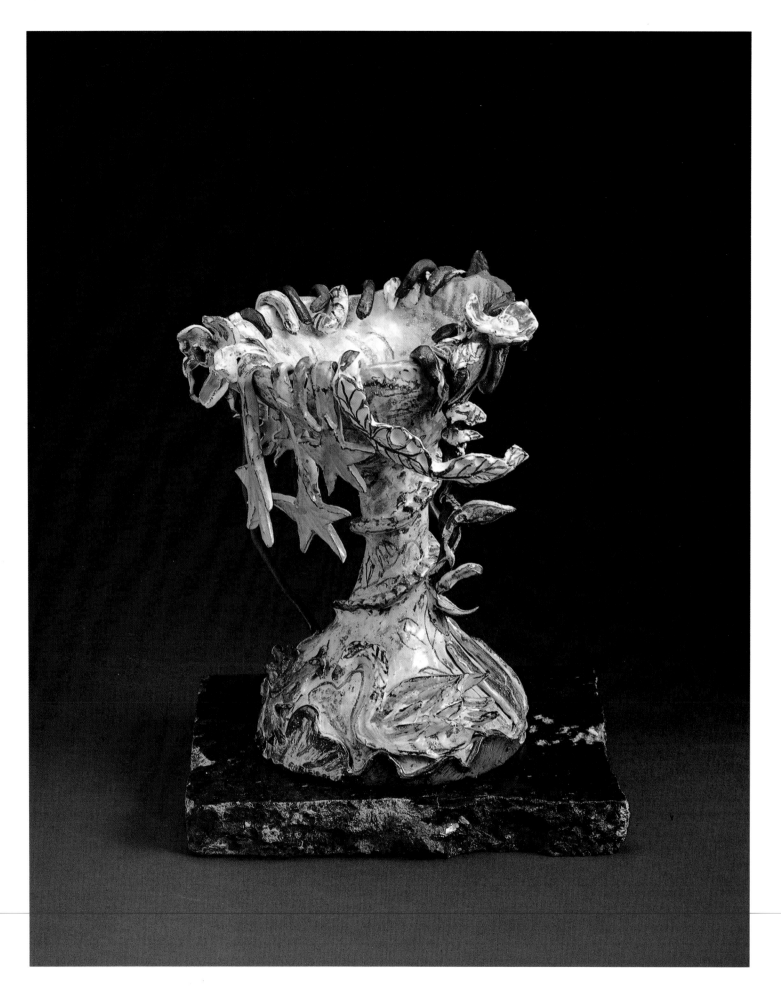

9

CERAMICS WITH SCULPTURAL INTENT

Clay as a medium offers a sculptor a material that can be directly transformed into images from personal experience. In some cases the resulting work is confrontational, using the shock value of colour or aggressive content with a calculated use of the physical presence of the work to question and involve the viewer in intellectual discussion. In some cases the work is figurative or narrative, and concerned less with the formal elements of sculpture, as with expressions of emotions and instincts.

Lorraine Jenyns' work has been called 'figurative satire'.[1] Lorraine Jenyns studied at the Caulfield Institute of Technology, the Royal Melbourne Institute of Technology and the Melbourne Teachers College in the sixties. Known nationally as a sculptor she is currently working in Hobart where she is teaching in the Ceramics Department of the University of Tasmania. In 1986 she received research grants from the University of Tasmania and the Tasmanian Arts Advisory Board. She describes her work: 'My most recent work has been a focus on the universal woman, Joyce, as mother, sister, goddess and cult image and takes the concept from the microcosm (the family) to the macrocosm (the universal deity). In doing this, *history* becomes *herstory* and earth's changes, including volcanic eruptions and glacial mountains of ice, flash before our eyes, and souls wing their way heavenward. Although I still make single pieces, in solo exhibitions, the work comes from a central concept or theme, and remains, for the most part, narrative. Themes often have a connection with dream, myth, magic and/or pre-history, drawing on conscious and unconscious feeling for source material. I strive towards a certain irrationality in my work with traditional proportions and perspectives unimportant.'

Lorraine Jenyns has always used a mixture of materials, combined with handbuilt clay forms, and in the last six years has used acrylic or enamel paints, pastels and crayons in conjunction with or instead of traditional glazes. The use of colour is of major importance to her: 'I see my work in terms of colour as well as form. From the beginning, contrasts of surface, matt and shiny, rough and smooth, with intense almost gaudy colour have interested me.'

Recently the scale of Lorraine Jenyns work has increased dramatically, making images of mountains with neon eruptions and ice fields. She takes the figure of a small votive mother goddess and makes her two metres tall. Some of her large sculptures are made from the assemblage of many smaller pieces, not necessarily

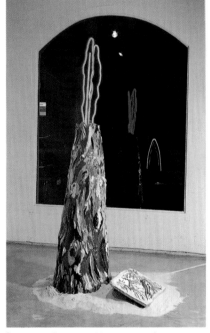

Lorraine Jenyns, *Erupting Volcano*, 1986

Christine Perks, *The Lovely Miss Cherry Divinity shepherds the flock – honing in on the heartland,* terracotta, majolica and coloured stains, 105 x 180 cm, 1986

1 *Studio Ceramics* by Joyce Warren, *Craft Australia Yearbook*, 1984

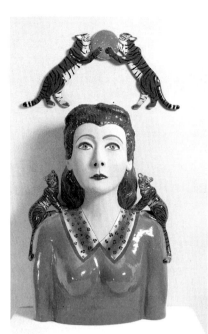

Lorraine Jenyns, *Joyce with Tigers*, 1986

(right) Lorraine Jenyns, *In the Begin-ning*, 1986

fixed, enabling the artist to vary the order at any time.

Lorraine Jenyns works in an intuitive way but acknowleges it is about power. 'Behind many of the pieces I feel the power of the object itself, maybe in the same way that objects or paintings were used for magical purposes in the past, as an unexplained secret imagery. Animals also play a strong role in my work, often associated with humans in a physical or magical sense with indirect reference to Freud's reality and pleasure principles with regard to the relationship of man and animals.'

James Draper studied interior design at the Sydney College of the Arts and then gained a Bachelor of Arts (Visual Art) from the Sydney College in 1981. Travel and working as artist-in-residence at the Sturt Workshops at Mittagong were also part

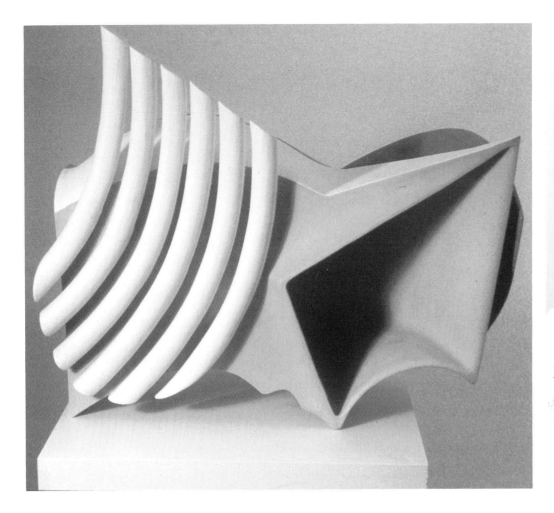

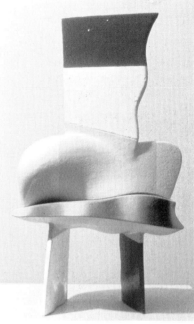

James Draper, Untitled, 56 cm/h, 1981

(left) James Draper, Untitled, 60 cm/h, 1982

of his study programme. Undertaking various commissions for sculptural ceramics and an exhibition schedule have engaged him since 1981. He writes: 'For the period from 1980 to 1985 I had been using the medium of ceramics to produce sculpture. These sculptures are not representational nor do they attempt to show personal experiences, feelings or emotions. They are about *likenesses*, sculptures which simply are in the manner of the sculpture of Arp, Brancusi, Clement Meadmore and Calder. The works are an exploration of their own physicality, of the relationship between form and space.

'The shapes used have no pre-existence, or association with an established image or recognisable thing. The turning inside out of a form or its repositioning produces another sculpture. My background in craft (for some years I have made pottery), and my studies in design have been to some degree an influence on the work.

'My sculptures display shapes and textures which juxtapose and abutt, subtle contradictions which are allowed to co-exist, a harmony of extremes (ostentation-meditative) movement, abstraction, power, change, expressionism, an order with a degree of instability. The most appropriate analysis would appear to be one of what the works do, rather than what they are and even less what they mean.'

Reviewing the work of James Draper, exhibited in *Faenza 1983*, Peter Emmett wrote: 'James Draper's three bold sculptural forms indicate a fresh and independent approach to form and material, the mass of the form is created by an interplay of simple planes, curves and contours but their conformity is broken by a surprise placement of extrusions, flat planes and openings. While they are formalist works, the idiosyncratic shapes, hard lines and pastel colourings conjur up a variety of perceptions and images in the eye of the viewer.'[2]

2 *Faenza 1983* by Peter Emmett, *Craft Australia*, 1983/2

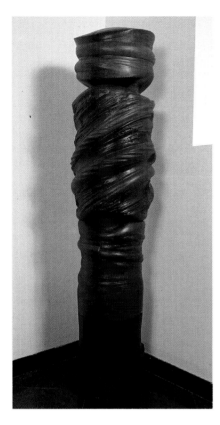

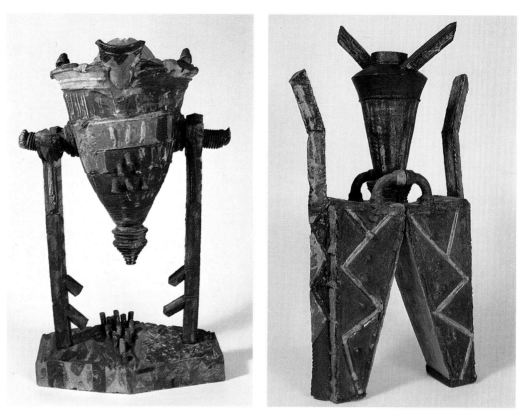

(left) James Draper, *Urban Shaft*, 2.1m/h

(middle) Robert Hawkins, *Crucible*, 1986

(right) Robert Hawkins, *Industrial Hybrid*, 1986

Robert Hawkins studied at the East Sydney Technical College and the Gramodaya Sangh.Khadi Institute in India. He received a Diploma of Education from the Sydney College of Advanced Education. He has been living and working in the Illawarra area, south of Sydney, where he says he has been 'drawing inspiration from the physical and social environs.'

'Making objects that testify to one's experience and perception of environment and self is my ongoing concern. I am overwhelmed by the drama of suspension and scale that dwarfs and often alienates the populus in a double bind of need and suffering. My works are generally overlaid with personal intent in idea and manner to create a more enigmatic and confronting object. It is sometimes this mood of precariousness versus weight, or security versus alienation in the object, that gives life to the emotions and confesses to a broader predicament in confronting paradox'.

Robert Hawkins works in a series, using a variety of forming techniques. He says: 'The first works in a series usually feel *pre-literate* as I sketch in clay and work on the edge of known and unknown gestures. Idea and piece evolve together. I find this process incorporates a valued commitment to change where intuition plays a strong role.'

In a review of Robert Hawkin's work in the *Mayfair Ceramics Award Show* Carl Andrews wrote: 'Robert Hawkins shows a group of works, two of which are bowl forms on tripod bases and evocative of another culture, in this case tribal African art. They are imposing and powerfully modelled yet vulnerable in the balance of bowl and base. This combination of strength and fragility creates an arresting tension. His *Bowl with Coathanger* forms are roughly structured sections of ceramic, built on to armatures of wire which emerge like reinforcement bars from demolished concrete slabs. This urban imagery is central to his later work.'[3]

It is suburban imagery that is currently attracting the attention of John Teschendorff. His large, narrative and occasionally confrontationist sculptures are

3 See *Pottery in Australia*, Vol. 23/2, 1984

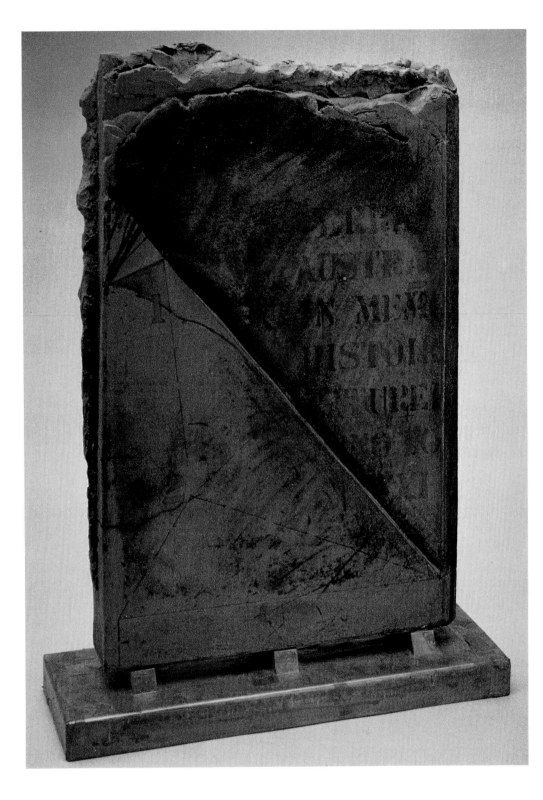

John Teschendorff, *Memorial II,*
terracotta, 1982

important in the recent development of Australian ceramics, particularly from the point of showing alternate ways of working, whilst still acknowledging the ceramic *presence* of the work. He writes: 'My works have always attempted to reflect the immediacy of my interaction with the environment. The *RO Series* and *Memorial Series* extended over six years, from 1976 to 1981. They were about Australian and English *landscapes,* surface and colour. The earliest were painted with automotive lacquer (hence the *RO* title – Raw Orange is a colour code from the Dulux automotive lacquer catalogue). I believe that my use of non-ceramic surfaces was the first serious attempt to use an alternative to glaze in Australia.'

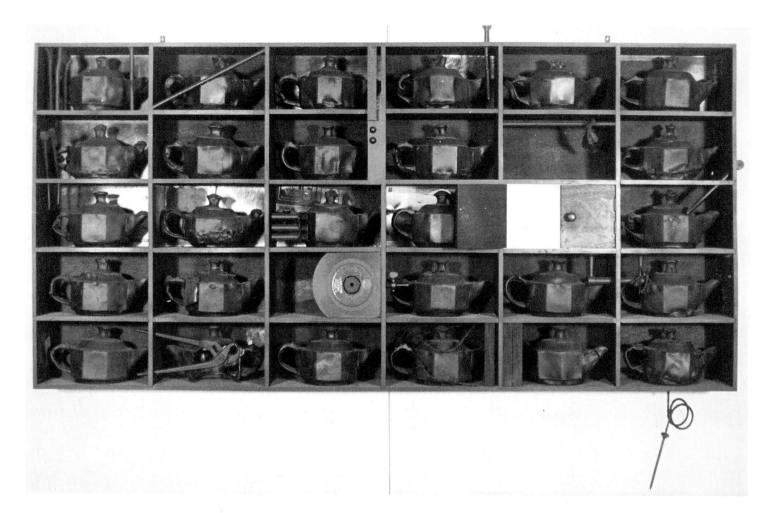

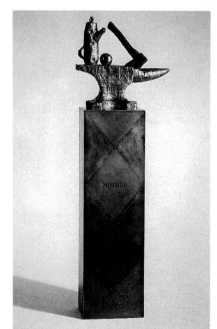

John Teschendorff, *Mother: Still Life IV*, 1982-85

(top) John Teschendorff, *Elegy for a Suburban Mother I*, 1981-82

4 Exhibition review of *Clothes and Clay* at the Orange Regional Art Gallery, for *Pottery in Australia.* Vol. 24/3, 1985

A need to reflect upon the suburban landscape 'became too powerful to ignore' and John Teschendorff's latest works explore his fascination with suburban existence... 'I made the first *Elegy for a Suburban Mother* in 1981, with its underlying notions of assemblage, motherhood, suburban angst and the role of the Australian male. For these works and the parallel *Still Life Series,* the works are more about the power of the object, however, than about ceramics.'

For the exhibition *Impulse and Form, Object makers and the Australian Experience,* shown at the Art Gallery of Western Australia in 1985, Robert Bell wrote for the catalogue: 'John Teschendorff's art attacks the suburban neurosis from within, presenting the familiar in a sinister form... he targets the mother, the central pivot in suburban drama... and perhaps in Teschendorff's controlled aggression we learn something of the dilemma of the suburban man.'

Currently Head of the Department of Visual Arts at the Murdoch University in Perth, John Teschendorff holds a Diploma and Fellowship of Art from the Royal Melbourne Institute of Technology and a Graduate Certificate from the Royal College of Art in London. He has had wide experience as a teacher and his work is represented in many public collections.

Peter Haynes, reviewing Teschendorff's work, wrote: 'John Teschendorff has adopted a self-conscious pose of confrontation. This confrontation is a multi-layered one, confrontation between artist and viewer, between viewer and work, between artist and work, between artist and artisan and between artist and ceramics. Teschendorff's pose is not an easy one, the work is concerned with not only pushing the definition of ceramics to the limit but in fact destroying those limits. Any preconceptions are attacked, not necessarily because they are wrong

Lorraine Lee, wall piece, 2m x .75m, 1986

(after all is there such a thing as *rightness* or *wrongness* in art?) but simply because they are there. The works offer us various visual entities which may or may not attract, whatever they certainly intrigue. Through such devices as the dull metallic surfaces, the enigmatic objects are presented not as objects in a still-life but as reverential objects in some form of unnamed religious liturgy, and the actual physical prescence of the pieces causes the viewer to come to terms with what the artist presents. Teschendorff is an artist who questions the viewer's values and perceptions.'[4]

Lorraine Lee left full-time teaching at the Art School in Hobart in mid 1984 to enrol in the Master of Arts course in ceramics at the Sydney College of the Arts. Originally gaining an Art Teachers' Diploma from the Tasmanian School of Art, Lorraine Lee then graduated with a Bachelor of Arts from the Tasmanian College of Advanced Education in 1977. Her latest work is based on a desire to move away from the rather precious and small scale decorative pieces for which she had become well known, to work in a larger, freer and more expressive way. Her earlier work, wall compositions and porcelain pieces, were described by David Hartmaier: 'Using clay, Miss Lee is able to bring forth from the surface of her tiles the familiar objects with which she works, creating a discord between dimension and object. The added dimension of light and depth increases the power of the composition which is not apparent in a photograph of her work.'[5]

Lorraine Lee describes her current work: 'I began by using one of the most basic and traditional ceramic objects, the cup and saucer, as a symbol with the power to generate historical and cultural association, in work dealing with perception and the interaction between seeing, knowing and expecting. I made a series of relief

5 *Ceramics with Class,* review in the *Melbourne Sun,* September 1981

Bronwyn Kemp, *Room Installation, the Sink* (detail), 1986

(right) Bronwyn Kemp, *Garden Folly,* terracotta, 50 cm x 1.3 cm

wall pieces consisting of cups and saucers, apparently floating in space, rising up the wall in formation, spiralling, basically ignoring their normal practical functions and becoming receptacles for ideas instead. This series relied on the use of perspective with the mutual reinforcement of illusion and expectation and the process of projection which is triggered off by recognition and supplemented by the information the viewer brings to the work.'

With an increasing interest in the power of an object out of context, with illusionistic space and working on a more psychological level, Lorraine Lee wants to question preconceptions in ceramics and the concepts of function, decoration and sculpture. She began working in a more intuitive way with geometric slab forms contrasted with softer ribbon-like and cloth-like elements which are personal symbols of dislocation, anxiety or instability. The use of perspective reveals the influence of Georgio de Chirico on her work. De Chirico parodied Renaissance perspective, which aimed at projecting a secure and believable space, by using it to create a network of conflicting spatial tensions that undermined the viewers' stability, giving them the feeling that they were hanging in a void.

'While painting deals with illusionary space on a flat plane, my work deals with real space and volume and is able to exploit further potential for a play between reality and actuality. The amount of ambiguity present in the work hopefully encourages more search for meaning in the possible interpretations of the image.'

Showing a similar involvement with space together with a concern for 'spiritual habitat', is Bronwyn Kemp. She says: 'Most of my work deals with the human environment. Space relationships and decorated surfaces that relate to spiritual and social aspirations of individuals or communities – especially that indigenous architecture that creates intimate and human scale – non-intimidating space. I am increasingly interested in using clay and making work that involves the everyday environment, stoves, and fireplaces, pipes, washing tubs, pathways, floors and walls and domestic pots. Most of my previous work has been small scale sculpture which

Christine Perks, *Fishing for a good time starts with throwing in your line*, assemblage, 45 x 54 x 30 cm, 1986

attempted to integrate these ideas but I am finding that scale of work increasingly limiting. The work is now moving away from the collectable into installation and perhaps commissionable environments.'

Bronwyn Kemp studied at the East Sydney Technical College, the South Australian School of Art and the Jam Factory Workshops in Adelaide. After a residency at the Griffith University in Brisbane she was appointed Head of the Jam Factory Ceramics Workshops, a position she currently holds.

John Neylon, reviewing the exhibition, *Thinking in Clay*, at the Contemporary Art Centre of South Australia, discussed Bronwyn Kemp's use of piazza and box motifs: 'Nothing in the Contemporary Art Centre's current exhibition intrigued more. The work was, at a technical level, an antithesis of the artist's meticulously crafted, polychromatic *Invader Boxes* and miniature dwellings produced in the early '80s. The medium in this case is sunbaked terracotta clay worked rapidly into courtyard configurations adorned with flora and fauna. For Kemp they continue to be reminders of spiritual habitats which neither white ants nor salt damp can consume.'[6] Reviewing the exhibition *Four Rooms + 2*, Garry Benson wrote': 'Kemp's Austral installation was a biting comment on the realities of living in Australia today – when you are down and out. The large gallery was fenced with corrugated iron, there was chookyard (complete with cacklers), and a very small draughty wooden shed that can apparently earn lots of loot for an enterprising landlord. It was very graphic, compelling and (at the end of the exhibition) a smelly environment...'[7] Of the same exhibition Peter Ward wrote: 'Her room is a beautifully constructed rusty corrugated iron and chicken wire fowl house of the kind everybody's grandmother had back in the '40s. The difference is that the birds – actual live pullets – get to nest and lay in the most elegant graffito decorated terracotta laying boxes ever to have been designed to be bird-limed. She has clearly never suffered from a cultural cringe towards things olde or new English.'[8]

Christine Perks graduated with a Diploma of Art from the Phillip Institute of

6 *Thinking in Clay*, Contemporary Art Centre of South Australia, review by John Neylon, *The Adelaide Review*, December, 1986

7 *Lost Rooms and Empty Chanoes*, review by Garry Benson, for *Artlink*, June/July 1986

8 Peter Ward, *The Australian*, March 1986

Technology in 1983. Since then she has been exhibiting her work in Victoria. For her, working in clay is like a 'celebration of mud'. She likes to let the clay and the piece itself dictate to her as she stands back and lets the handbuilt form under construction grow 'organically'. 'Handbuilding is an essential element of my work' she says, 'I use terracotta clay and use majolica glazes, oxides, underglazes and lustres to decorate the work. I find colour fascinating and try to create a layered effect that adds depth to the surface as well as complimenting the texture of areas left unglazed. Lustre is also a favourite, either as a highlight or for total impact. There is something wonderfully vulgar about lustre that invites and seduces me into overworking pieces.'

'Christine Perks was born in close proximity to the Great Dividing Range,' Peter Hook writes, 'near the once baudy, then prosperous gold rush town of Ballarat in Central Victoria. Ballarat, rich in both natural and material beauty through the opulence of its boom style Victorian architecture and bountiful flora and fauna, provides a wealth of visual imagery for this sensitive and perceptual artist. The titles and content of many of her ceramic works reflect the character of her town of origin and play a strong and essential part in both the motivations and understanding of her creative output.

'Her later travels provided additional historical and philosophical insights. The vitality and mocking humorousness of her work, with its flamboyance of construction and colour, is further enhanced by diverse references to popular contemporary culture such as the words of Tom Waits, *fishing for a good time starts with throwin' in your line*. The title of a dessert, *Cherry Divinity Pie*, in a popular family supermarket publication, initiated works with the august titles of *The Holy Grail Measuring Cup for Cherry Divinity* and *The Lovely Miss Cherry Divinity Shepherds the Flocks honing in on the Heartland*.

'Christine Perks's works are boldly constructed with terracotta clay and are richly decorated true to the Majolica seen on her travels, combined with the underglazes and lustres discovered in her Art School experience.' Peter Hook concludes, 'One suspects that despite a possible initial reaction to the work to see only its playfulness and incongruity, the work represents, as with the beginnings of Ballarat itself, an insight into deeper traditions and emotions shrouded, not by mist but by glorious fantasy.'

Frederic Chepeaux's cultural background, his travels and his languages have given him 'a perpetual curiosity and a fair amount of iconoclasm'. This is reflected in his work which has essentially dealt with the human condition working each exhibition with a single theme, with titles like *Mutation*, or *Growth*, or *Packaging, Wrapping and Trappings* or *Fallen Air Symbols*; this device enabled him, through the number of pieces in an exhibition to move from the personal to the universal. He says: 'It is my belief that art is communication and that certain beauty can be unpleasant, aestheticism is not the paper tiger that so many contemporaries like to surround themselves with at the whims of an interior decorator or short sighted art critic. I have no intention to follow this advice and blunt my meaning.

'I landed in Australia in January 1969 in the middle of a craft revival. It was a revolution about identity, individuality and self-expression. Although it might have originated in America or Europe, its transplant in Australia became aggressively national, albeit peaceful, almost from the onset. This revolution was attractive in all its facets. It levelled new and old Australians, it was inclusive, not exclusive of non-white, non-male input; I could do nothing but join wholeheartedly such a generous undertaking. The high tide of the late sixties and early seventies created its own crisis; in Australia it broke down to a question of numbers,

Frederic Chepeaux, *Air Symbol Failed*, porcelain and mixed media, 83 x 86 x 27cm

makers versus buyers. It created a need to identify, classify, to label a who's who in the crowded rank of makers. I fared well with a grant from the Australia Council, some work purchased for State Gallery collections, twenty three solo exhibitions, selected for many group exhibitions and commissions and a two month long retrospective in a Regional State Gallery. I can say that my work helped me, but how? From the outset I was outside the classifications, I had always been making work other than pottery. I made images; the fact that only a component of my work is

Frederic Chepeaux, *Deaf to Oneself, Love to Live, Live to Love*, multi media, 98 cm/h

(top) Frederic Chepeaux, *Winged Angel*, 1985

(far right) Robert Bell, *Paesaggio Frammento*, porcelain, 1983

9 *Near and Far*, Exhibition review by Hillary Merrifield, *The West Australian*, 1968

clay does not limit me or specialise me in any way, except in pushing its techniques further towards the embodiment of my ideas; but so do other materials and their techniques. I have become known as a multimedia sculptor simply because I believe that when you make an idea visible you cannot bend, limit or cripple that idea on account of shortcomings in your technical or manipulative skills.

'My allegiance to the craft movement is greater than the one I could have towards the art movement; craft still has an honesty with adherence to quality and finesse of execution. From a maker's point of view I do not agree with a divorce between idea and technique, or that the first transcends the second to the point of ignorance.

'Louis Kahan, during the opening of one of my exhibitions in Melbourne had this to say: "Chepeaux defies classification, is he to be called a surrealist or a symbolist, a sculptor or a painter, a cabinet maker or a mason? He is all of these things. Above all, he is a philosopher. Having the tradesman's approach, he does not believe in waiting to be kissed by the Muses. Temperament and inspiration with capital letters is nonsense to him. He seeks work as a physical thing, an energy source, and, I suspect as a sensual experience."'

In the past years collectors have supported Chepeaux's work, fostering his ongoing processes and developments. He says: 'There is no room in our society for an artist ignorant of chronology or history and not consciously aware of his or her place in the present. A compromise on the quality of the work for the sake of selling now calls for a non-existent future through the great filter of time.'

Robert Bell received his Associateship in Design from the Western Australian Institute of Technology in 1966. He has been exhibiting ceramics, fibre and drawings since 1968 when critic Hillary Merrifield wrote: 'Robert Bell is primarily concerned with the visual and tactile qualities of his materials, which include aluminium, glass, wood, plastic, paint and clay. His rough pots and ceramic sculpture have the spontaneity and tactile appeal of Japanese *Raku* ware or natural boulders or gemstones. His work reveals an adventurous spirit and honesty of intention...'[9]

Exhibiting, travelling, writing, lecturing and being involved in craft organisations, Robert Bell is currently Curator of Craft at the Art Gallery of Western Australia. He writes about his work: 'Working in ceramics is for me a way of expressing ideas rather than a desire to continually provide the world with objects. It is a sporadic process and because of that and because I also work in other materials like fibre, my output is limited. When I began working with ceramics in 1967, I was interested in primitive and rock-like forms, drawing influences from travels in Central America, Africa and Japan. The mid-1970s saw a distillation of these ideas into large slab forms, black glazed, incised and occasionally combined with fibre. I used a laborious hand building process with earthenware as a base for gestural marks and incisions, a way of working I enjoy and to which I am now returning. Around 1979 I switched to working with slip-coated and coloured, marbled porcelains, making small assemblages of incised slabs, shards and classical elements alluding to classical architecture and its relationship to ceramics and other objects. Funerary architecture and ornamentation is a pervasive interest and found expression in this series of works.'

In an article on Robert Bell in *Craft West* in 1978, he is quoted as saying: 'My pieces highlight the clash between the modern world (the world of building facades, grilles and gratings) and the natural world that is left.' In a statement, written for the exhibition, *Elements of Change*, at the Crafts Council Gallery, Sydney in 1982, Robert Bell said: 'Working in porcelain has made me interested in its tradition and

Robert Bell, *Time Gate*, porcelain, silk,
lead, 32 x 33 cm, 1979

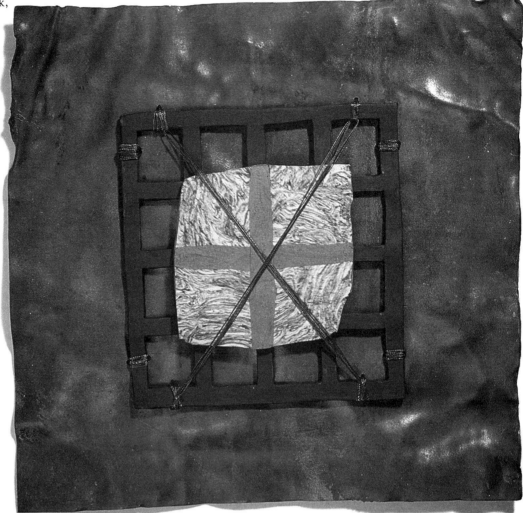

its relationship to classical architecture and commemorative ritual. I am using
material in a more intense and concentrated way, while allowing the objects to
exist in random, scattered assemblages... A continuing series of work plays with
concepts of transience and permanence, illusion and memory and the intense and
mythical nature of materials like lead, porcelain, marble, gold and silk used in a
primitive formalism. The razor line between life and death, permanence and
memory, fantasy and reality and the magic qualities of materials are factors which
dominate every aspect of my life and work.'

'Elements of the landscape are important in the work of Robert Bell.' Susan
Malm wrote for the exhibition catalogue of *Ceramics – Objects and Figures:* 'In his
work he draws on the drama of harsh light and shade of the Australian landscape
and on the perceived relationship of man (and his structures) to the land which
surrounds him. Bell approaches his subject in a way which one could describe as
architectural... a sense of monumentality... a strength of form. References to
twentieth century technological developments are subtle – he uses lustres and stark
mono-chromatic surfaces in combination with grids and crosses, and contrasts
these with the more organic forms within the pieces. Bell also uses the architectural
elements of the pieces symbolically; passage-ways are formed, the walls create

10 *Ceramics – Objects and Figures,* Catalogue for
the exhibition, University Fine Arts Gallery,
University of Tasmania, 1983

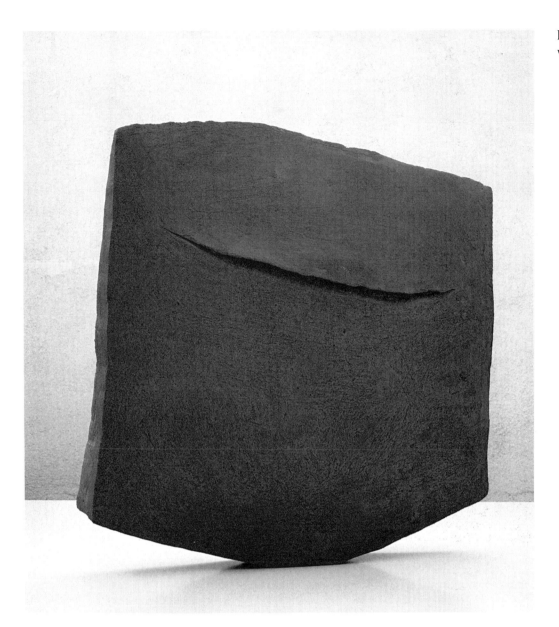

Robert Bell, *Breath*, glazed earthenware, 41 x 41 x 9 cm, 1974

barriers and the grids point to divisions and classifications created by *civilization*.'[10]

Robert Bell is now returning to the larger scale work that he 'is happiest with, using coarse, undecorated clays in a minimal way. I enjoy the patterns and currents of the fashionable world, but,' he says, 'I prefer to keep it from my own ceramic work, to keep it floating in time, as a memory of my view of the world during my life.'

'The ends of the last four centuries have been marked by major developments in ceramics,' Robert Bell said at the 4th National Ceramic Conference.[11] 'Tin-glazed Majolica, Delftware in the seventeenth century, stonewares and the influence of the Industrial Revolution through Wedgwood in the eighteenth century, the rise of the artist potter in the nineteenth century to the ceramic hydra of the twentieth century – at once primitive, expressive, mass produced, elitist and popular. What character will the twentieth century be seen to have had through its ceramics; what is the relation between a stoneware utensil and a porcelain-clad building, between expressive sculpture and industrial design, between contemporary art practice and the persistence of tradition? I believe that the potter of the twenty-first century will draw on a rich tradition and it is interesting to speculate on what the late twentieth century might offer.'

11 *Renaissance Revisited – Ceramics and the Ends of Five Centuries*, paper for the session *2001: A Clay Odyssey* at the 4th National Conference, Melbourne, 1985

10

THE JOYS OF COLLECTING CERAMICS

Ceramics are part of a nation's cultural heritage and a collector can serve the community by keeping alive a care for art and beauty, acting as a patron to today's ceramist. There is much diversity to be seen in the works of art represented in this book but all are the original expressions of artists working in Australia today; they show not only considerable technical skills but personal character and style. These ceramics being made today are representative of the ideas in our own society. It is not enough just to look at the photographs, but to see and touch for oneself and learn to judge good work.

One way to learn about ceramics is to look for them in collections such as museums and art galleries where they on view to the public. To own ceramics, however, for use every day, or for special occasions, as art to decorate the home, or as a statement with which to concur or disagree, is a direct, first-hand method of acquiring knowledge and understanding of the potter's art. In this way one can learn the subtleties of the forms, colours and textures, the styles and ideas of individual artists and new movements in the ceramics field. One can experience the potter's achievments directly, not just behind museum glass or at the whim of the curator's collecting choice, if one becomes a collector oneself. The more one knows, the more pleasure and enjoyment one is able to obtain from the whole development of the art form. It is a timeless art and we have the opportunity to see and collect our own cultural heritage while it is still happening.

Collecting should always be out of a real liking for the works of art. Although ceramics do have an increasing value for investors, it is one's own pleasure and love of art that offers the most important reasons for collecting. One can cultivate knowledge by attending exhibitions and following the work of various artists and then with heightened interest spread the awareness of ceramics throughout the community. This can be rewarding by affording pleasure to the collector and viability to the artist. As artists flourish so is the whole community benefitted. The collector is able then to form a judgement on new works, decide whether they are just fashion or genuine works of art.

This book, in its *let the artist speak* format , offers first hand information on the intentions of the artists and current events in ceramics in Australia. Let the artists have the last word.

Victor Greenaway comments: 'Public awareness of craft has grown enormously over the years I have been a potter. There is a need in modern society to relate to

Maggie McCormick, bust 55 x 40 x 12 cm

Martin Halstead, *Instrumental* 60 x 23 x 20 cm

tangibles, something real and hand made. People are becoming more interested in craft as collection items, in the same way as paintings and prints, so the incentive for making objects is becoming more exciting for the potter and the future as a craftsperson more possible.'

Simone Fraser sees a diversity in the collecting habits of Australians. She says: 'Perhaps Australia's large flat land leads our collecting instincts towards paintings and wall hangings but our practicality insists on objects being useful rather than decorative. While clay and other formerly exclusively craft materials are being used by artists to interpret and comment on our life, the qualities of clay are underexplored and little appreciated. I would like to think that ceramics, glass and wood can fill the spaces in our environment left by a preoccupation with decorating walls. Pots, for example, can be intimate and personal sculptures, icons for a modern society. My work is highly personal and produced for myself but I hope that its appeal is general and that it can function as decorative art in many environments.'

Penny Smith writes : 'No matter what is written about the *how* of making clay objects, and the people that make them, the *why* often appears simplistic. How does one explain passion, or desperate necessity? The serious collector of ceramics can respond to many of the forces that direct the makers. A discerning collector can recognize and empathise with the aspirations of the maker, through warmth,

1 *Social Reflections in Clay; the place of the potter in society today and tomorrow*, Potters Conference 1983 Adelaide. See *Pottery in Australia*, Vol. 22/2, 1983

Stephen Benwell, vase 50 cm high,
1986, collection of the Australian
National Gallery

vigour, generosity, strength, vulnerability, timelessness, fashion, fun and so on.
The teapot is, for me, symbolic of many of these and as such, is a constant vehicle
for magical interpretation.'

Robert Hawkins: 'I believe the eighties are an exciting time for Australian
ceramics. A broader view on the part of ceramists, gallery directors and the public
is emerging. It is important for us all to be looking at the role that individual artists
can play and feel confident in the diversity of work that is apparent.'

Frederic Chepeaux: 'A buyer needs to take the same courage and risks that the
artist took in making those images. There is no comfort in being an artist, no
insurance scheme... True collectors understand this. At heart, they are gamblers,
and they trust their own choices.'

Jeff Mincham summarised ceramists' attitudes when he wrote:[1] 'Some of us
impose limits on our experiences, set boundaries and come to believe in certain
truths. Others are never happy with such limitations and seek to push back
boundaries. We can see ourselves as traditionalists, experimenters, or as expressive
idealists. Some of us allow our initial learning experiences to shape our progress,
others search for new ideas and ideologies. Some are worshippers and some are
iconoclasts – but all makers have one thing in common, a desire to be understood,
valued and appreciated.'

Freya Povey, *Vanessa, the Undresser from the Silver City Show,* 59 x 24 x 18 cm

Glossary Of Technical Terms
A brief explanation of terms used in the text:

Clay: A mineral used by potters for its ability to hold shape and be permanently changed by fire. A CLAY BODY is a mixture of clays and other minerals to produce a working material formulated by a potter for particular qualities of colour, texture and vitrification temperature. One clay body is EARTHENWARE, which remains porous when fired to a temperature of around 1100° Centigrade. This is also called TERRACOTTA. Stoneware is a strong vitreous clay body fired to 1300° Centigrade and PORCELAIN is a white translucent clay body usually fired over 1300° Centigrade. BONE CHINA is a blend of clays, minerals and bone ash to produce a translucent body which can be fired at a lower temperature than porcelain. CLAY SLIP is a liquid mixture of clay and water used for decorating and forming shapes in moulds.
Forming methods: Clay can be shaped by THROWING on a potter's wheel, and then TURNED when the piece is LEATHER HARD, (stiff enough to hold its shape, but not too hard to cut;) or built by hand using SLABS or COILS or simply PINCHING with the fingers; or by SLIP CASTING, using liquid clay slip poured into plaster moulds to form shapes. The use of a mould and template on a revolving wheel to form shapes is a process called JIGGER and JOLLEYING.
Glaze: A glass like layer melted on the surface of fired clay to give colour, texture and to render it non porous. Glazes may be classified according to their main or characteristic ingredient, for example, TIN glaze, tin is a opacifying agent and is the glaze used in producing *MAJOLICA* ware; DRY glaze refers to its surface quality; RAW glaze indicates the glaze is applied to the ware when the ware is unfired. Many potters fire their ware twice, the first firing called a BISQUE firing to harden the ware and facillitate the glazing process. Some glazes have traditional names, such as *CHUN* glaze, a blue glaze with opalescent qualities originating in 11th Century China, *CELADON*, a high temperature green to grey glaze also seen on early Chinese pots, *TENMOKU*, a black or dark brown glaze from Japan, and *SHINO*, a traditional Japanese glaze which is thick and white and often with red flashings. SALT glaze is formed by the vaporising of sodium and other chlorides in a kiln and produces a textured surface on the ware. UNDERGLAZES are blended coloured pigments used for decoration by brushing or spraying on the work; OXIDES are the raw colouring pigments for decorating under or over the glaze layer; ENAMELS and LUSTRES are usually applied to the surface of a fired glaze layer and refired to a fusing temperature. The process of FUMING is done by applying volatile chemicals to the surface of the piece during cooling for surface effects.

Kilns: Kilns can be classified as to fuel, for example GAS, OIL or WOOD burning. *ANAGAMA* kilns and *BIZEN*-style kilns are traditional Japanese kilns for use in making natural ashed glazed wares. PRIMITIVE, or BONFIRE kilns are for producing LOW-FIRE ware, obtaining a maximum temperature of about 800° Centigrade. The use of a refractory box inside a kiln and filling the box with vegetable and other combustible material for localized effects is called SAGGAR FIRING. BLACK FIRING is a method of filling the whole kiln with combustible material at the end of a firing for smoking the ware, the carbon produced by the burning material colours the clay black or grey. A *RAKU* kiln is used for a traditional Japanese technique, and can be fired with any fuel. Easy access is needed to withdraw the ware from the kiln at its maximum temperature for further smoking or fuming procedures.

Public Museums & Art Galleries
with Collections of Ceramics

VICTORIA

National Gallery of Victoria
180 St. Kilda Road, Melbourne, 3000.

Geelong Art Gallery
Little Malop Street, Geelong, 3220.

Castlemaine Art Gallery
Lyttleton Street, Castlemaine, 3450.

Bendigo Regional Art Gallery
View Street, Bendigo, 3550.

Ballarat Fine Art Gallery
40 Lydiard Street, North Ballarat, 3350.

Sale Regional Arts Centre
Civic Centre, MacAlister Street,
Sale, 3850.

Shepparton Art Gallery
Civic Centre, Welford Street,
Shepparton, 3630.

La Trobe Valley Regional Art Centre
138 Commercial Road, Morwell, 3840.

Benalla Art Gallery
By the Lake, Benalla, 3672.

SOUTH AUSTRALIA

The Art Gallery of South Australia
Adelaide, 5000.

TASMANIA

Tasmanian Art Gallery and Museum
Hobart, 7000.

**Queen Victoria Art Gallery
and Museum**
Launceston, 7250.

WESTERN AUSTRALIA

Art Gallery of Western Australia
Perth, 6000.

Fremantle Art Centre
1 Finnerty Street, Fremantle, 6160.

NORTHERN TERRITORY

**Museum and Art Gallery of the
Northern Territory**
Darwin, 5790.

AUSTRALIAN CAPITAL TERRITORY

The National Gallery of Australia
Canberra, 2600.

QUEENSLAND

Queensland Art Gallery
Brisbane, 4000.

Brisbane Civic Centre Art Gallery
City Hall, King George Square,
Brisbane, 4000.

Perc Tucker Gallery
Flinders Mall, Townsville, 4810.

NEW SOUTH WALES

Art Gallery of New South Wales
Art Gallery Road, Sydney, 2000.

Museum of Applied Arts and Sciences
Mary Ann Street, Ultimo, 2007.

Manly Art Gallery and Museum
West Esplanade, Manly, 2095.

The Lewers Bequest Gallery
Penrith Regional Gallery
86 River Road, Emu Plains, 2750.

Bathurst Regional Gallery
Bathurst, 2795.

Orange Civic Centre Gallery
Byng Street, Orange, 2800.

Newcastle Region Art Gallery
Laman Street, Newcastle, 2300.

Broken Hill City Art Gallery
Choloride Street, Broken Hill, 2880.

Albury Regional Art Centre
546 Dean Street, Albury, 2640.

Commercial Galleries showing Ceramics

AUSTRALIAN CAPITAL
TERRITORY

Narek Gallery
Cuppacumbalong Craft Centre,
46 Naas Road, Tharwa, 2620.

Beaver Gallery
81 Denison Street, Deakin, 2600.

Crafts Council of the A.C.T. Gallery
1 Aspinal Street, Watson, 2602.

NEW SOUTH WALES

Australian Craftworks
The Old Police Station,
127 George Street, The Rocks, 2000.

Berrima Galleries
Hume Highway, Berrima, 2577.

Cook's Hill Galleries
65-67 Bull Street, Newcastle, 2300.

Crafts Centre Gallery
100 George Street, Sydney, 2000.

David Jones Art Gallery
7th Floor, Elizabeth Street Store,
Sydney, 2000.

Holdsworth Gallery
86 Holdsworth Street, Woollahra, 2025.

Inner City Clayworker's Gallery
Cnr, St Johns Road and Dargan Street, Glebe, 2037.

Kenwick Galleries
14a Hannah Street, Beecroft, 2119.

Lake Russell Gallery
Pacific Highway, Coffs Harbour, 2450.

Macquarie Galleries
204 Clarence Street, Sydney, 2000.

Mori Gallery
56 Catherine Street, Leichhardt, 2040.

Old Bakery Gallery
22 Rosenthal Avenue, Lane Cove, 2066.

Pastoral Gallery
Old Cooma Road, Queanbeyan, 2620.

The Potter's Gallery
48 Burton Street, Darlinghurst, 2010.

Seasons Gallery
259 Miller Street, North Sydney, 2060.

Sturt Pottery and Shop
Range Road, Mittagong, 2575.

Von Bertouch Galleries
61 Laman Street, Newcastle, 2300.

Watters Gallery
109 Riley Street, East Sydney, 2010.

Weswal Gallery
192 Brisbane Street, Tamworth, 2340.

VICTORIA

The Bridge Gallery
242 Yarra Street, Warrandyte, 3113.

The Craft Centre
309 Toorak Road, South Yarra, 3141.

Devise Gallery
263 Park Street, South Melbourne, 3205.

Distelfink Gallery
432 Burwood Road, Hawthorn, 3122.

The Elgin Gallery
61 Elgin Street, Carlton, 3053.

Gallery Indigenous
14 Rose Street, Armadale, 3143.

Gryphon Gallery
Melbourne C.A.E. Cnr Gratton and Swanston Streets, Carlton, 3053.

Laburnum Gallery
9a Salisbury Avenue, Blackburn, 3130.

Meat Market Craft Centre
42 Courtney Street, North Melbourne, 3051.

Potters Cottage
Jumping Creek Road, Warrandyte, 3113.

Powell Street Gallery
20 Powell Street, South Yarra, 3141.

SOUTH AUSTRALIA

Studio 20
Blackwood, 5061.

This is Apt
Shop 79 Westfield, Tea Tree Plaza,
Modbury, 5092.

Quality Five
47 City Cross, Adelaide, 5000.

L'Unique
Adelaide City, 5000.

Greenhill Galleries
140 Barton Terrace, North Adelaide,
5006.

Jam Factory Gallery
169 Payneham Road, St. Peters, 5069.

TASMANIA

Handmark Gallery
44 Hampden Road, Battery Point,
7000.

Crafts Council of Tasmania Gallery
77 Salamanca Place, Hobart, 7000.

Salamanca Place Gallery
65 Salamanca Place, Hobart, 7000.

Saddler's Court Gallery
Richmond, 7025.

Bowerbank Mill
Bass Highway, Deloraine, 7304.

Oakwood
Midlands Highway, Mangalore, 7030.

The Design Centre
Launceston, 7250.

QUEENSLAND

The Potter's Gallery
483 Brunswick Street, Fortitude Valley,
4006.

Victor Mace Gallery
35 MacDougall Street, Milton, 4064.

Crafts Council of Queensland Gallery
166 Ann Street, Brisbane, 4000.

WESTERN AUSTRALIA

**Crafts Council of Western Australia
Gallery**
Perth City Railway Station, Wellington
Street, Perth, 6000.

Greenhill Galleries
20 Howard Street, Perth, 6000.

Black Swan Gallery
46 Henry Street, Fremantle, 6160.

NORTHERN TERRITORY

**Crafts Council of the Northern
Territory**
Bullocky Point, Fannie Bay, 5790.

Reference Books & Magazines

CARDEW, MICHAEL, *Pioneer Pottery*, Longman.
CHARLESTON, ROBERT, J., *World Ceramics*, Hamlyn.
CLARK, GARTH, *Ceramic Art and Review*, E. D. Dutton.
COOPER, EMMANUEL, *A History of World Pottery*, Batsford.
HOARE, J. AND ANDERSON B., *Clay Statements*, Darling Downs Press.
HOPPER, ROBIN, *Functional Ceramics*, Chilton Book Company.
LANE, PETER, *Studio Ceramics*, Collins.
LANE, PETER, *Studio Porcelaine*, Collins.
LEACH, BERNARD, *A Potter's Book*, Faber and Faber.
MANSFIELD, JANET, *Pottery*, Collins.
MOULT, ALAN, *Craft in Australia*, Reed Books.
TIMMS, PETER, *Australian Studio Pottery and China Painting*, Oxford.

Periodicals

Craft Arts, P.O. Box 363, Neutral Bay Junction, Sydney, 2089.
Craft Australia, 100 George Street, Sydney, 2000.
Craft Australia Yearbook, 100 George Street, Sydney, 2000.
Pottery in Australia, 48 Burton Street, Darlinghurst, Sydney, 2010.
Potters' Directory, 48 Burton Street, Darlinghurst, 2010.

Index of Names

Bruce Anderson
Neville Assad
Rod Bamford
Jane Barrow
Gail Barwick
Robert Bell
Stephen Benwell
Sandra Black
Les Blakebrough
Joan Campbell
Frederic Chepeaux
Greg Daly
James Draper
Diogenes Farri
Simone Fraser
Marea Gazzard
Victor Greenaway
Andrew Halford
Martin Halstead
Robert Hawkins
Patsy Hely
Victoria Howlett
Harold Hughan
Lorraine Jenyns
Michael Keighery
Bronwyn Kemp
Eileen Keys
Gudrun Klix
Patrick Lacey
Lorraine Lee
Carl McConnell
Maggie McCormick
Vincent McGrath

Ivan McMeekin
Sony Manning
Janet Mansfield
Jeff Mincham
Milton Moon
Alice Nixon
John Odgers
Graham Oldroyd
Jenny Orchard
Susan Ostling
Stephanie Outridge-Field
Dianne Peach
Alan Peascod
Christine Perks
Gwyn Hanssen Pigott
David Potter
Freya Povey
Ben Richardson
Brett Robertson
Peter Rushforth
Owen Rye
Bernard Sahm
Bill Samuels
Mitsuo Shoji
Derek Smith
Penny Smith
Hiroe Swen
John Teschendorff
David Walker
Toni Warburton